FARFETCH CURATES FOOD

ASSOULINE

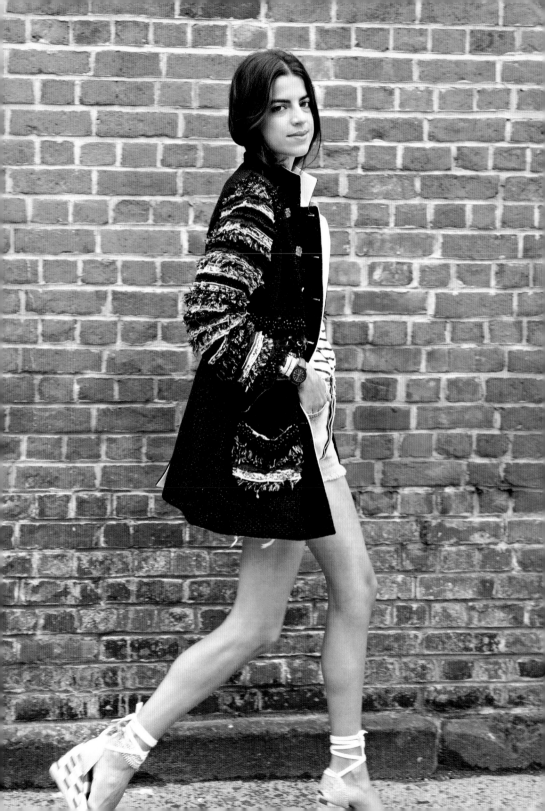

CONTENTS

4 INTRODUCTION BY TIM BLANKS

BREAKFAST

6 BREAKFAST WITH ELETTRA WIEDEMANN

10 THE BREAKFAST CLUB

16 HEALTHY MEASURES VS. GUILTY PLEASURES: BREAKFAST

18 THE GUIDE TO MODERN COFFEE

LUNCH

22 LIGHT LUNCH WITH THE MAN REPELLER

26 SINGAPORE'S NEW FOOD FIGHTERS

32 CAFÉ COUTURE

38 HEALTHY MEASURES VS. GUILTY PLEASURES: LUNCH

AFTERNOON TEA

40 THE PERFECT CUP OF TEA

44 A PARISIAN PASTRY TOUR

DINNER

48 DINNER OFF THE BEATEN PATH

58 THE NEW FASHION CAPITALS

68 WOMEN IN WINE

72 A VEGETARIAN IN TOKYO

AFTER DINNER

76 ICONIC COCKTAILS

82 HEALTHY MEASURES VS. GUILTY PLEASURES: AFTER DINNER

84 WINDING DOWN WITH JONATHAN SAUNDERS

86 FARFETCH DISCOVER

92 DIRECTORY

96 CREDITS

Leandra Medine, founder of the blog *The Man Repeller,* in SoHo, New York City. See page 22 for the full feature.

WHAT'S EATING TIM BLANKS?

When the cultural history of these times is written, I have a feeling one figure will loom large: the Curator. Once, curation was a specialist expertise largely confined to the art world. Now, technology has turned everyone into curators. But the Internet – The Great Leveler – has replaced expertise with force of personality. That's now the hook you need to fish authoritative opinion out of the bottomless ocean of information that the Web has unleashed.

Farfetch Curates Food is the first fruit of a grand alliance between fashion boutique marketplace Farfetch and publishers Prosper and Martine Assouline, and, appropriately, fruit is all over the book. As are breakfast, lunch, afternoon tea, cocktails, dinner, and more cocktails. Charismatic enthusiasts from all over the world have been canvassed for their insights and recommendations. Because it's Farfetch that is doing the canvassing, there is inevitably a modish slant, but this, too, seems entirely appropriate, because while the relationship between fashion and art has flourished, fashion has also been enjoying a bit on the side with food. They're a very compatible couple. The original Paleo dieters would have first consumed the beast they'd hunted down then wrapped themselves in its skin.

Occasionally, you'll hear fashion described as an international language, but food fits that bill too. There's no better basis to explore a new geographic environment (especially when the local fashion outlets are likely to be selling labels you're familiar with from your homeland). A restaurant find is the natural concomitant of a backstreet retail discovery. It's the kind of information that fashion nomads trade like stocks and bonds. And that is, in fact, a curatorial activity. You're collecting, editing, exhibiting your taste to others.

I, for one, love any kind of recommendation that relates to food and drink, so I'll be devouring this book with a knife and fork... or maybe my hands, if that seems more... what was the word again? Ah, yes, appropriate.

BREAKFAST WITH ELETTRA

As the daughter of Isabella Rossellini, it's little wonder Elettra Wiedemann fell into the world of fashion as a teen. But the multilingual model, biomedicine graduate, and *Vogue* 'vlog' presenter's obsession with food comes as more of a surprise. In her blog, *Impatient Foodie,* Wiedemann focuses on the local sourcing of seasonal ingredients and her exploratory cooking approach, presenting success stories as well as humorous failures. At home in New York, she whipped up breakfast for Farfetch while telling us how she fell in love with all things culinary:

My family would always eat together, and we'd talk about our lives, so I have warm memories associated with food. My mother never let me eat junk food as a child and because of the food I was raised on, I tend to crave and gravitate towards food that is fresh and homemade. I find all of my ingredients at the farmers' market in New York City. However, now and again, I do love a piece of cake, and I have a weakness for French fries and mayonnaise.

Opposite and following page:
Elettra Wiedemann at home.

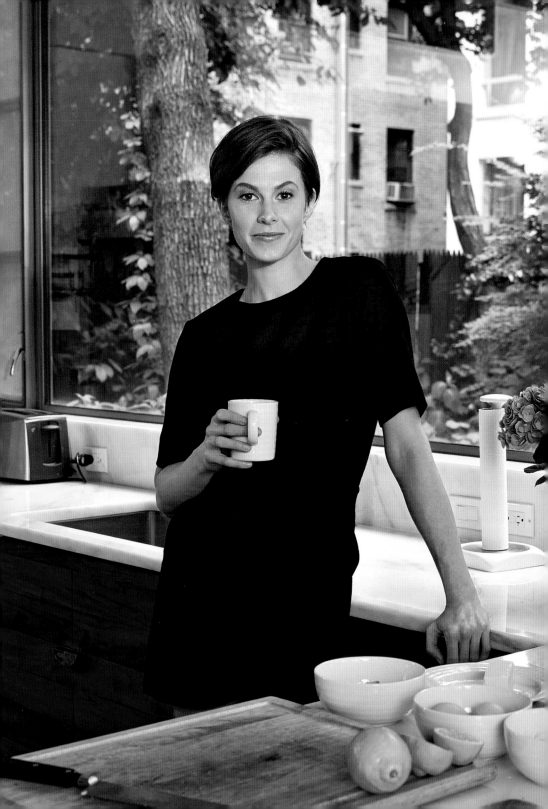

" I tend to gravitate towards food that is fresh and homemade.**"**

Elettra Wiedemann

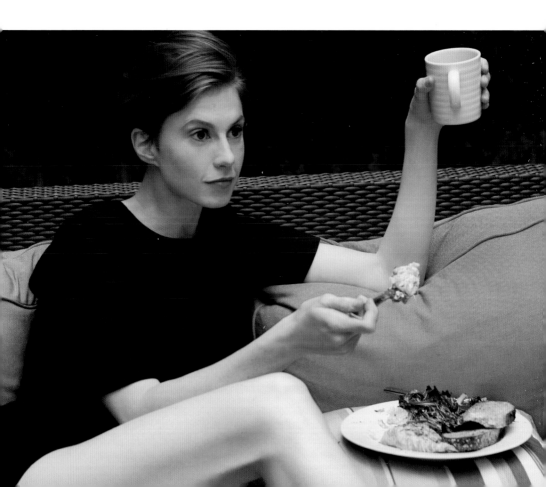

I've always loved to eat, but I became really passionate about cooking and food during my studies at the London School of Economics. Being scrupulous about what you purchase has a major impact on not only your health but also your family's health, your community, and even the planet at large. It sounds cheesy, but it's true! I want to make smart food choices, but I have a busy and demanding life. This juxtaposition was the impetus to start *Impatient Foodie*. It's really more of a journal, and it helps me to figure out how to balance my food desires with my life constraints.

I also created *Elettra's Goodness*, which was a show on *Vogue*'s channel for one season, and in each episode, I cooked with a different friend. Cooking and eating are the ultimate connectors, and I wanted to recreate the vibe and atmosphere of friends cooking a dinner together.

I love to discover new recipes through friends, and to share my recipes with friends, including this one for the perfect omelette. Containing a hearty helping of protein, a breakfast omelette is a healthy and energy-fuelling way to start the day. Use butter sparingly or replace it altogether with coconut oil to keep it lighter, and go heavy on the seasoning for a delicious yet guilt-free morning maker:

ELETTRA'S OMELETTE

INGREDIENTS

3 free-range eggs (*I get mine from the Union Square Greenmarket every Monday*)

1 knob of butter or 1 tsp coconut oil (*available in most health food stores*)

salt and freshly ground black pepper

Elettra's Healthy Omelette fillings (*optional*): sautéed leek and rosemary / kale and cayenne pepper / mushroom and artichoke

PREPARATION METHOD

Crack the eggs into a bowl; beat with a fork until smooth and then season. Melt a knob of butter or heat 1 tsp of coconut oil in a non-stick frying pan. Sauté the fillings, and pour the eggs into the pan when the butter or oil is piping hot. Using a wooden fork in a circular motion, move the eggs in the pan around whilst moving the pan back and forth across the heat. Allow the eggs to form a light skin, and then remove the pan from the heat. Using the side of a fork, fold the omelette in towards the middle on both sides. Tip the omelette onto a plate, and serve.

THE
BREAKFAST
CLUB

With its network of global boutiques, from Spain to America's Deep South, the Farfetch community extends over many cultures and culinary traditions. Here, five Farfetch boutiques recommend the most intriguing and delectable breakfasts from around the world:

AUSTRALIAN

The fry up down under, **PRIMITIVE LONDON,** *U.K.*

'As a native Australian, I find there is something really refreshing about eating runny eggs, crispy bacon, and avocado spread on sourdough bread on a hot summer Sydney morning. In the wild colonial days, this would have been accompanied with rum, but if you need a morning caffeine boost, Australian coffee is also world class.'

— Andrew Grune, creative director, Primitive London

> **PRIMITIVE LONDON RECOMMENDS:** Nothing beats a breakfast with a cold glass of something bubbly beside the spectacular Sydney Harbour... sunshine free of charge.

INDIAN

Vegetable-stuffed flatbread and crispy pancakes, **LE MILL**, *Mumbai, India*

'With twenty-nine states, and each state having its own cultural heritage, India is a very diverse breakfast nation. Traditionally, North Indian breakfast is heavy – vegetable - stuffed flatbread, accompanied with a spicy pickle and yoghurt. South Indian breakfast is lighter – steamed crispy pancakes made of ground lentils with chutneys.'

— *Cecilia Morelli Parikh, owner, Le Mill*

LE MILL RECOMMENDS: For South Indian delicacies try Mumbai's **Konkan Café,** or check out Mumbai's **Kailash Parbat** for a North Indian experience.

AMERICAN

French toast with fresh berries, **LINDA DRESNER,** *Birmingham, Michigan, U.S.*

'The best southern American breakfast is French toast, good French Roast coffee, berries with drizzled balsamic glaze and fresh basil, served with an Egyptian Tomato Salad. I served this at my house to a governor running for president, and he swooned. He didn't win the election, but he did love my breakfast.'

— *Linda Dresner, owner*

LINDA DRESNER RECOMMENDS: The **Pink Tea Cup** in Brooklyn for the most divine Deep South dishes.

NORDIC

Rye bread with cold cuts, **HENRIK VIBSKOV,** *Copenhagen, Denmark*

'Our national breakfast is rye bread, a kind of dark bread made up of many grains, served with cold cuts of meat or fish, strong cheese, eggs, and jam. I love a multigrain rye bread from Schulstad, topped with Agnes, a very strong cheese. I grew up eating this every day.'

— *Henrik Vibskov, owner*

HENRIK VIBSKOV RECOMMENDS: The **Kaffebar** at Elmegade in Copenhagen serves freshly baked rye bread with butter and an egg with salt on the side.

SPANISH

Churros and hot chocolate, ELITE, Marbella, Spain

'Churros remind me of early morning family gatherings. My father would buy a bunch of churros and wake everyone up with their smell; it was a great cause for joy! This is the perfect breakfast if you enjoy a mix of salty and sweet flavours. They are also the perfect hangover cure.'

— *Alejandro Gutiérrez, PR Manager and buyer, Elite*

> **ELITE RECOMMENDS: Churreria Ramon** in downtown Marbella. Not only is the location simply amazing, but they do the best churros I've ever tasted.

HEALTHY MEASURES

THE BODY GOOD JUICE

MELVIN'S JUICE BOX, *New York City, U.S.*

This juice is full of healthy green vegetables – kale, collard greens, Swiss chard, celery – and it's packed with vitamins, minerals, and chlorophyll to regenerate the body. Ginger and lemon are great for cleansing, and you also get a dose of vitamin C. After drinking our Body Good Juice, people feel less bloated, more focused, have increased energy levels, brighter eyes, and a clearer complexion. You can't go wrong!

VS. GUILTY PLEASURES

Farfetch's favourite breakfast drinks

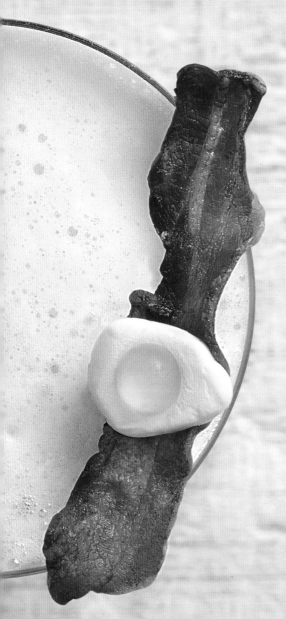

THE BACON & EGG MARTINI

THE LONDON COCKTAIL CLUB, *London, U.K.*

This martini is made up of bacon whiskey, egg white, maple syrup, lemon, and bitters. It was created in 2009 after the founder of The London Cocktail Club was lucky enough to be invited by Sir Raymond Blanc to work for two months at the legendary restaurant and culinary school Le Manoir aux Quat'Saisons. Inspired by Blanc's creative pairings, the cocktail is based on 'gastromixology', a concept that brings food and drink together in fun ways that people can relate to.

THE GUIDE TO MODERN COFFEE

Tim Wendelboe is the owner of the eponymous, award-winning Oslo roastery, renowned for its dedication to achieving the perfect roast. At the roastery's attached espresso bar, Wendelboe reveals to Farfetch how to create the perfect coffee blend, placing focus on sustainability, freshness, and quality:

Coffee has changed radically since I started as a barista in 1998 in one of the first modern coffee shops in Norway. Back then I did not drink coffee. The bitter and harsh flavours were too offensive for me. Coffee was an everyday product and a fuel, mostly sold as a blend to make sure it always tasted the same.

Today coffee has grown up. The best kinds are sold by variety, using single producers from the best regions. Farmers need to grow and separate different coffee cultivars in order to find the ideal one for their growing conditions. On the other hand, roasters and baristas have better technology and equipment to bring out the beans' full potential in the final brew. Even the best restaurants in the world are taking their coffee as seriously as their wine.

So what makes some coffees taste better than others? Here are seven steps for mastering the perfect blend:

Espresso. *Following page:* Café Latte.

1. Buy lighter roasts for less bitterness, enhanced natural acidity, and flavour. However, the roast shouldn't be too light or it will make the coffee taste like dried peas, hay, and grass. When the coffee is roasted well, it should be sweet, low in bitterness, and have distinct flavours that reflect the cultivar from where it originated and its terroir.

2. Coffee generally tastes best within four weeks of roasting, if packed in an airtight, sealed bag. Look for the roast date on the bag, not the expiration date, and stay away from paper bags. They do not protect the coffee from oxidation, and the coffee inside will taste stale.

3. Buy your beans from roasters and retailers who know their product, care about their suppliers, and are likely to pay them fair prices for their coffee. If you want to explore the diversity in coffee flavours, then buy single-origin coffees and not blends. Look for information about the farm, cultivar, and process on the bag.

4. Get yourself an adjustable burr grinder. Pre-ground coffee loses aroma and oxidises much faster than whole beans. It is also important to be able to adjust the grind. If your coffee tastes too bitter, grind coarser; if your coffee tastes sour and weak, grind finer.

5. You need clean, soft water with neutral pH to make good coffee. Hard water with high mineral content (more than 150 mg/l) makes coffee taste bitter and unpleasant. Make sure your equipment is clean before you start brewing.

6. Whether you use an AeroPress, a tière, or a filter cone for brewing your coffee, accurate measurements are key. I recommend using sixty to seventy grams per litre (1,000 grams) of water. If the coffee is too strong or weak, I prefer to adjust the grinder, leaving the dose the same, but you can adjust the dose as well.

7. Try coffee without milk or sugar. Great coffee is naturally sweet, and the flavours are easier to taste when the coffee is served without any additives and cooled down a bit. The better the quality of the coffee, the better it will taste.

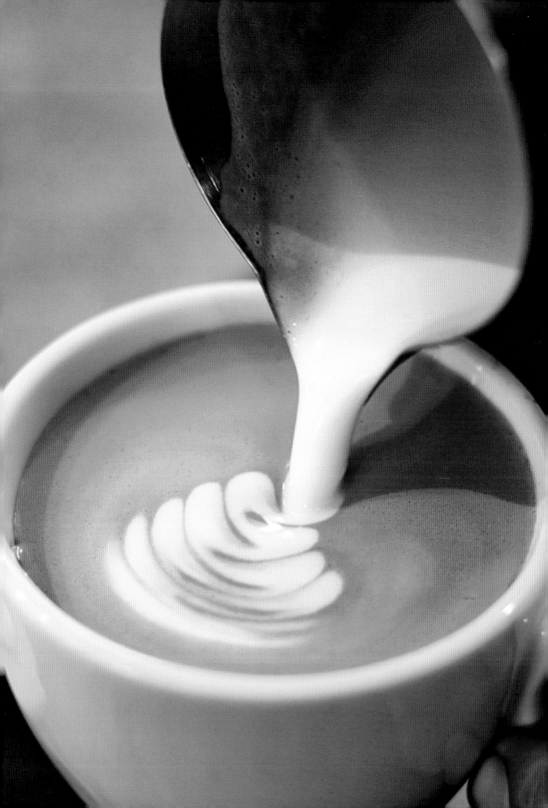

LIGHT LUNCH WITH THE MAN REPELLER

With her blend of piquant wit, experimental style, and singular insight, Leandra Medine is known for her utterly distinct musings on high fashion. The New York City native founded her blog *The Man Repeller* in 2010, and can be found strolling the city's streets in fabulous heels, with a kale lollipop or iced coffee in hand. Both a fashion and a food enthusiast, Medine revealed to Farfetch her top spots for a healthy lunch in New York City:

Leandra Medine at Sant Ambroeus, Lafayette Street, New York City.

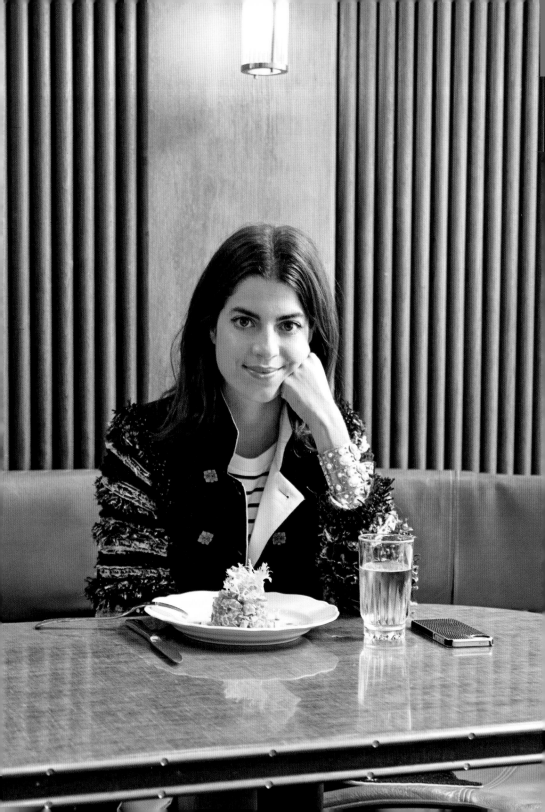

SANT AMBROEUS

SoHo

Sant Ambroeus draws a really nice crowd, and on weekdays for lunch, it almost feels like I am at Fashion Week. I grew up near the Upper East Side location on 78th Street, so when Sant Ambroeus opened up a location in my new neighbourhood downtown, I made it my business to become a regular. **WHAT TO EAT:** The Quinoa Salad. **WHAT TO WEAR:** Ivory leather culottes and a white blouse. **FAVOURITE MEMORY:** Lunch here with my older brother, Haim, on Saturdays.

Sant Ambroeus, Lafayette Street. Jack's Wife Freda.

JACK'S WIFE FREDA

SoHo

The atmosphere is exactly what a neighbourhood restaurant should be, feeling as if you're in your living room, but you don't have to cook or clean up. **WHAT TO EAT:** The Greek Kale Salad. **WHAT TO WEAR:** My attitude towards dressing for this restaurant very much reflects their ostensible ethos, which is, that anything goes! Just eat! **FAVOURITE MEMORY:** I ate here two years ago with nine girlfriends, after volunteering for Hurricane Sandy.

SETTE MEZZO

Upper East Side

I first ate here when I was really young. My parents and grandparents have lunch together there every Sunday. I usually go when I'm with one of my parents, or for a sibling's birthday. **WHAT TO EAT:** The Insalata Bianca. **WHAT TO WEAR:** Probably a Saint James striped shirt with high-waist white silk pants and loafers. **FAVOURITE MEMORY:** Sharing a slice of orange cake with my grandmother.

Sette Mezzo.

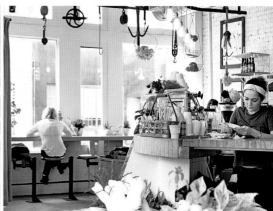

The Butcher's Daughter.

THE BUTCHER'S DAUGHTER

Nolita

I love the bleached wood counters and simple décor that mirror the genre of this café's food, which is for the most part very clean and nearly vegan (they do serve eggs). They make a killer coconut yoghurt and serve cashew cheese that makes me want to do the cashew dance. **WHAT TO EAT:** The Egg Sandwich. **WHAT TO WEAR:** Fancy sunglasses. **FAVOURITE MEMORY:** Saturday morning breakfasts of oatmeal with cashew milk, and reading the newspaper.

SINGAPORE'S NEW FOOD FIGHTERS

As editor and founder of *Makansutra*, a guide to Singapore's greatest eateries, writer KF Seetoh is an unrivalled expert on the city's latest food trends. Farfetch tapped Seetoh's talents to help seek out the hippest new names to make their mark on Singapore's delicious street food history:

By night, Douglas Ng could be mistaken for a K-pop celebrity, often seen relaxing, dining, and enjoying the town's vibrant nightlife. But by day, Ng works on highlighting his familial food heritage at his stall, **Fishball Story.** Earlier this year the entrepreneur walked away from his business, Chinese restaurant 3+1, and began documenting, then refining his grandmother's Mee Pok Tah (fish ball noodles) recipe. He took a hawker's space, the local term for street food vendors, in Beach Road's Golden Mile Hawker Centre, and he can be seen hand-pressing up to 600 Ping-Pong-sized balls made entirely of fish paste, at 5 a.m. every day. At under four dollars a portion, the dish yields rather slim margins, but as Ng says,

Douglas Ng, founder, Fishball Story.

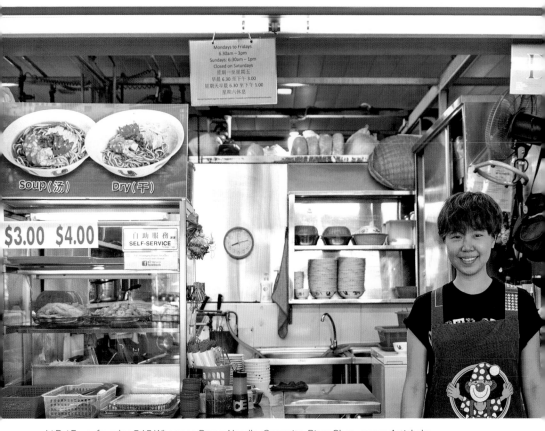

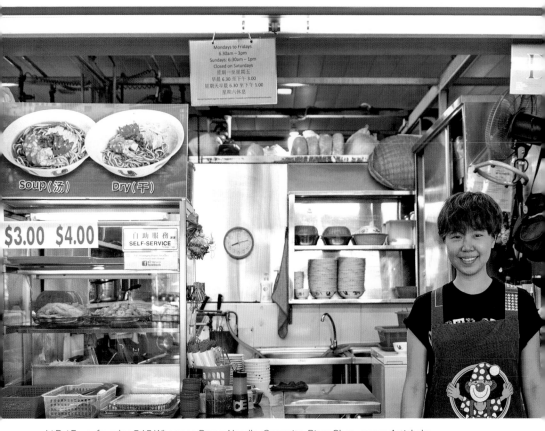

Li Rui Fang, founder, 545 Whampoa Prawn Noodle. *Opposite:* Bjorn Shen, owner, Artichoke.

'I just want to protect my family's food culture because not many in my generation are doing that. It's not a good thing to lose.'

Another vendor determined to preserve her heritage is Li Rui Fang, a thirty-year-old noodle seller with an economics and finance degree. After a few uneventful years as a settlements manager, she quit her job and returned to Singapore. She began helping her parents, as she had done during her youth, making prawn noodles at her father's forty-year-old stall. In 2014, she set up her own branch, **545 Whampoa Prawn Noodle,** selling the same recipe, with her parent's blessing.

These inspiring individuals are part of the next generation of sellers, campaigning against the status quo in a metropolis known for constant progression.

The hawker movement began fifty years ago, when travelling street food vendors were relocated from their often dilapidated areas to permanent residences, known as hawker centres. These centres offered basic functions like seating, water, electricity, fans for cooling, and drainage facilities. Each centre had up to 150 small-scale stalls. Today, there are more than a hundred hawker centres. Originally created to

reduce environmental harm, they produced an unintended but agreeable effect – the preservation of Singapore's migrant comfort food culture. At any one time, there are sellers offering Chinese, Indian, Malay, Nonya, British, Japanese, and Singapore street food. Think prawn noodles with sambal, Indian mee goreng inspired by the Chinese wok, and Hainanese curry rice, created with ideas borrowed from Japanese, British, and Indian curry cultures, all of which have a place in old Singapore history.

There are varying types of street food vendors. Some are focused on continuing the culinary traditions, while others, like Chua Kiat Tat, have taken a different trajectory. **Salute,** his traditional coffee shop (*kopitiam,* as the locals would say it), which is located in the district Bukit Merah, houses several stalls in one food court. Based near a row of car mechanic workshops, Salute was mostly frequented by workshop employees until Chua Kiat Tat, a former shipping executive, took over

the lease with his father. The two began reinventing Salute, lowering rents so vendors could spend more on ingredients and inviting chefs who specialised in affordable gourmet food, rather than the foods traditionally associated with street food in Singapore.

One similar project, which predates Salute, is **Alibabar,** a corner shop kopitiam based near East Coast Road in Katong. The new owner, Tan Kay Chuan, installed barstools and café-style seating, hired a mix of Western and local hawkers, and now operates a bar laden with artisanal craft beers and fine coffee. Alibabar has a commanding view of the busiest junction in this famous neighbourhood, and the location itself is unconventional, bordering on dangerous, as buses negotiate a bend that veers precariously close to your seating area, although this has only made the venue even more of a draw.

Between independent and forward-thinking kopitiams, hawkers refining family recipes, and an overall new way of thinking, there's been an organic evolution in Singapore's food scene.

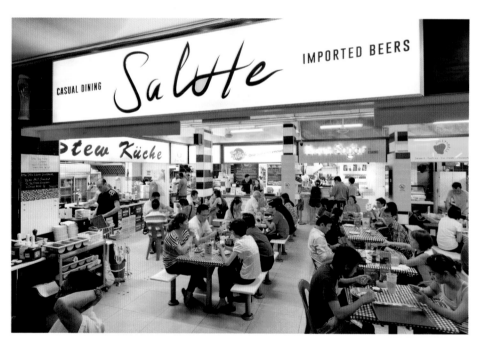

Salute. *Opposite, clockwise from top left:* Prawn Noodles from 545 Whampoa Prawn Noodle; Fishball Noodles from Fishball Story; and Noodles from Artichoke.

KF SEETOH ALSO RECOMMENDS:

ARTICHOKE
Modern Middle Eastern cuisine

MIÀN BY THE TRAVELLING C.O.W.
Modern takes on local food

BROWN SUGAR BY ESKIMO
Bubble tea and gourmet coffee

IMMANUEL FRENCH KITCHEN
Classic French cuisine

TWO WINGS
Specialists in local dish Carona Chicken Rice

STEW KÜCHE
Traditional German cuisine

CAFÉ COUTURE

Farfetch boutiques aren't just coveted shopping destinations; many also offer perfect pit stops for grabbing a gourmet bite. Whether you're after a post-shopping smoothie or lunch with magnificent mountain views, here are five of our favourites:

RENAISSANCE

Antwerp, Belgium

Housed in the ModeNatie building, the focal point of Antwerp's revolutionary fashion scene, **Renaissance** boutique is a triumph of Belgian minimalism. Its clean lines and monochrome interior extend to its sophisticated restaurant, which boasts high ceilings and marble finishes. Offering up delicious Italian cuisine, this is the ultimate end to an afternoon spent browsing Kenzo and Repossi – the charcuterie board is essential sharing fare.

> **FARFETCH RECOMMENDS:** If you are a fan of fish, the tuna tartare and sea bass carpaccio make for the tastiest entrées in Antwerp.

ANASTASIA BOUTIQUE

Laguna Beach, California, U.S.

Within walking distance of Laguna Beach's pristine coastline, **Anastasia Boutique** brings a touch of the avant-garde to its Ocean Avenue home. Pore over cutting-edge designs by Rick Owens, Gareth Pugh, and Issey Miyake before unwinding over Eggs Napoleon or Belgian Waffles in the elegant café. A seat on the patio is a must in the summer.

FARFETCH RECOMMENDS:
The Chicken Satay and Pain Caramel Toast are essential for splurging, and the green juice is the perfect health fix.

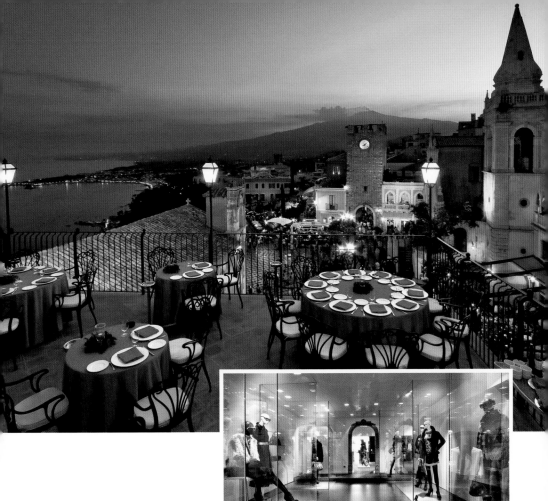

LA BARONESSA

Taormina, Italy

The Parisi family owns seven stores lining Taormina's meandering Corso Umberto I. Making your way from menswear at one end to accessories at the other builds up an appetite. Just as well, then, that the family owns a spectacular restaurant, perched on a rooftop with panoramic views of Mount Etna. Dine on Sicilian cuisine served by attentive waiters, and bask in the knowledge that this is as good as it gets.

FARFETCH RECOMMENDS: The best seat in the house is the corner table, overlooking the spectacular coastline. Ask Alfio to reserve it when you book.

CONCEPT 13

Warsaw, Poland

Occupying two floors at the top of Vitkac, Warsaw's most luxurious shopping emporium, **Concept 13** draws the city's elite to dine on sophisticated, modern European cuisine in between shopping from the best international collections. Grab a table by the window or, better still, on the balcony outside to enjoy sweeping views of Warsaw city centre, as you sip wine from the vast selection and enjoy dishes prepared in the open kitchen.

> **FARFETCH RECOMMENDS:** The tomato soup is a must. You may question just how good a tomato soup can be, but once you've had this, you will never think of it in the same way again.

BOWERY

Brussels, Belgium

The Smets family owns twenty-one coveted boutiques across Luxembourg, most of them carrying the family name. Their Premium Store, located in Brussels, boasts a glamorous French eatery. Indulge in a punch-packing cocktail in **S-Bar** before taking in panoramic views from **Bowery,** the restaurant on the top floor. With eclectic, colourful décor and works of contemporary art, the restaurant is a visual splendour. The menu is equally inviting: Lobster ravioli or foie gras are perfect for easing your post-splurge hunger.

FARFETCH RECOMMENDS: Never underestimate a hamburger! Bowery elevates this fast-food favourite to the highest level, especially when it's washed down with a glass of Beaujolais.

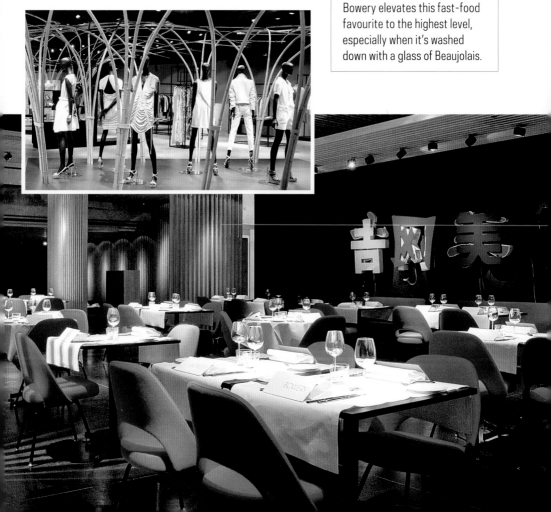

HEALTHY MEASURES

DON CEVICHE

CEVICHE, *London*

Don Ceviche is thought of as the daddy of ceviches. It is called *Don* as a mark of respect – the same term of address used for people in Spanish-speaking countries who have earned respect through sheer brilliance. It uses sustainably farmed sea bass, red chilli, sweet potato, red onion, lime juice, salt, and coriander. The dish is packed with tons of healthy components, such as high levels of protein from the fish; from the chilli, vitamins C and A and minerals iron and potassium, which also have anti-carcinogenic and anti-bacterial properties; and from the limes, with more vitamin C plus flavonoids (great for digestion and a very good fat burner)!

VS. GUILTY PLEASURES
Farfetch's favourite seafood lunches

BISQUE MAC 'N' CHEESE

LE BUN, *London*

This dish comprises perfectly al dente macaroni, oozy red pepper rouille, Gruyère croûtes, the freshest prawns around, and, of course, the bisque sauce. We love to combine our favourite, classic dishes from across the pond, so we set ourselves the challenge of mixing divine French Bouillabaisse with true American Mac 'n' cheese, which on paper shouldn't work! We took inspiration from Julia Child, who introduced French cooking to the masses in the States in 1963, and used many of her old-school recipe elements, but instead of making a straight-up Bouillabaisse, we applied them to a bisque, and voilà!

THE PERFECT
CUP OF TEA

Native Canadian Jens de Gruyter opened his minimalist Berlin teashop **Paper & Tea** in 2012 to encourage the tea-curious to discover the intricacies of flavour and brewing techniques. Farfetch enlisted de Gruyter to explain the subtleties involved in creating the perfect cuppa:

Tucked away in Berlin's Charlottenburg district, Paper & Tea is a mecca for any tea enthusiast. Founder de Gruyter advocates a purist approach to tea and imports high-grade varieties from countries such as Taiwan, China, Korea, and Japan. 'From the picking to the processing, everything is done by hand and by artisans who have made tea for generations,' he says.

Be it a grassy green tea or an Indian Darjeeling, the shop's teas are presented in unsealed petri dishes, in order of oxidation, ready to be smelled and sampled. The aromas of caramel from a South Korean black Woori tea are a far cry from an over-processed packet bought in a supermarket.

Paper & Tea offers personal tea tastings, and de Gruyter will explain to his guests as they sample his specialty teas, 'We are going to taste tea "gong fu" style' – an approach to perfecting tea through time and repeated brewing for a truly unique experience.

Second best to being at Paper & Tea, de Gruyter reveals to Farfetch the following secrets to securing the perfect brew:

Paper & Tea.

REVOLUTIONISE YOUR BREWING

The practice of precise brewing is completely different from what we are used to in Europe. Follow two rules: not too hot and not too long. Never heat black teas above ninety degrees Celsius, white teas above eighty, or green teas above seventy. Heat changes the amino acids found in tea, which are responsible for its aroma and sweetness.

MAKE IT MATCHA

When selecting high-end teas, pick them for their active ingredients. For example, Matcha is a high-end Japanese green tea, made of powder that was finely ground down from whole leaves. True matcha is rich in antioxidants and has the same amount of vitamin C as three oranges. It's also full of flavonoids, anti-carcinogenic chemicals, and is high in caffeine.

KEEP IT KOREAN

Green tea enthusiasts have their favourites, but most probably don't know about Korean teas. The Chinese pan-heat their green tea to prevent oxidation, and the Japanese steam it, but Koreans use both methods, giving the tea a distinct flavour. Tea was brought to Korea by Chinese Buddhist monks, but was later banned. Now its government works with tea growers, and so do we.

MASTER ECONOMICS

You can brew high-quality tea multiple times, and if you don't use too much of the leaf, this becomes quite economical. Hardly any of our teas are more expensive than your average cup, as you can brew them two, three, or four times. With each steeping, the flavour of the tea changes, allowing you to focus more on the taste.

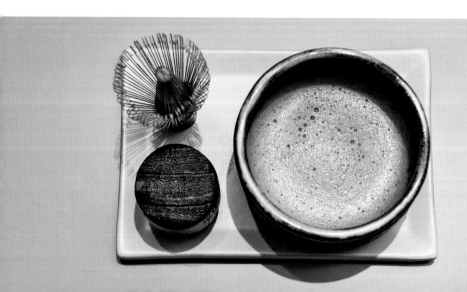

CHILL OUT

Cold brewing is very popular in Japan. It involves taking a good whole leaf tea and brewing it in cold water. Let the tea brew a little longer than a hot brew, allowing it to release its ingredients. Green, white, and oolong teas are best for cold brewing. They can even have a more intense flavour than when they are hot.

REINVENT YOUR RECIPES

Use tea as an ingredient or pairing. Matcha has an amazing natural aroma and flavour profile and is used in both savoury and sweet cooking. Some white teas have vegetal and sweet aromas and are often paired with light entrées. Korean black teas have earthy berry profiles and are usually served with sweet desserts, and yellow tea is commonly paired with cheese.

TEA: THE GLOSSARY

Essential words and phrases for the modern tea connoisseur:

CHASAKU (JAPANESE): A bamboo tea scoop used for measuring matcha tea powder – an essential part of the 'Way of Tea', the Japanese matcha tea ceremony.

CHASEN (JAPANESE): A bamboo whisk used to stir matcha tea. To achieve perfect matcha foam, whisk briskly in W-shaped strokes.

GAIWAN (CHINESE): A brewing vessel used for the infusion of tea leaves and then for drinking the tea.

GONGFUCHA (CHINESE): A Chinese tea ceremony, involving the ritualised preparation of tea, designed to maximise flavour.

This page: Chinese Pu Er Bai Ya White Tea.
Opposite: Chasen Tea Whisk and Matcha.

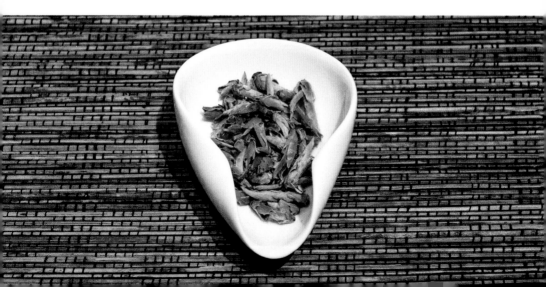

A PARISIAN
PASTRY TOUR

Chefs Christophe Adam, Sébastien Gaudard, and Christophe Michalak, all trained at international gourmet house Fauchon, are now utilising their learnings to put choux pastry firmly back on the Paris culinary map. Here, Farfetch learns how each chef is bringing creative change to the world's pastry capital:

CHRISTOPHE ADAM
L'ÉCLAIR DE GÉNIE

'I have enough éclair ideas for the next ten years,' boasts Christophe Adam, owner of L'éclair de Génie. So far, he's brought salted caramel, fig and raspberry, and lemon meringue éclairs to the table, all proudly displayed at his conceptual store in le Marais.

Airy and minimal, L'éclair de Genie is far removed from an old-school patisserie. Posters of seasonal promotions and mood boards showcasing the source of various chocolates grace the walls. 'It's very important for me to work in a relaxed atmosphere with my team,' says Adam, clad in his uniform of grey jeans, Converse sneakers, and a casual shirt. 'I'm creative by nature, so brainstorming new store graphics is as fun as éclair recipes.' With plans to open patisseries in Tokyo (Adam says he hopes to build on the Japanese love for pastries with his éclairs), Dubai, Switzerland, and New York, his business is set for stratospheric success.

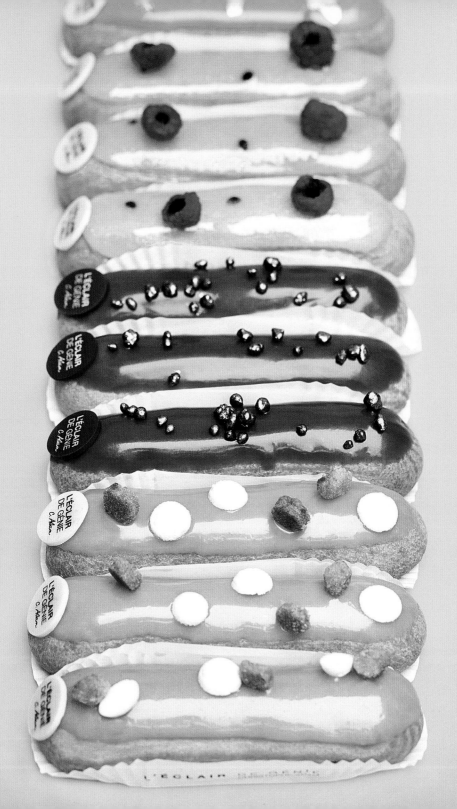

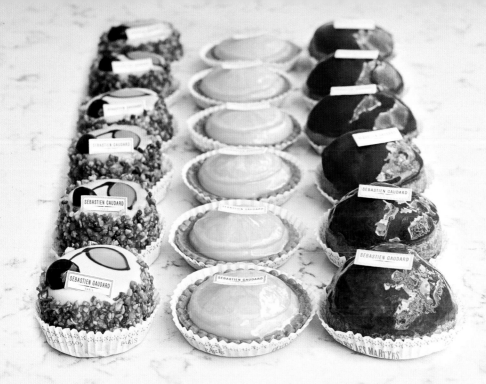

SÉBASTIEN GAUDARD

SÉBASTIEN GAUDARD

Anybody who has worked under Fauchon's Pierre Hermé, a chef dubbed 'the Picasso of Macarons', is bound to have high expectations placed upon him. That's the story for Sébastien Gaudard, trained by some of the most prestigious chefs in Paris, and now head of his formerly family-run eponymous patisserie, Sébastien Gaudard.

In the basement kitchen of the patisserie, a team of accomplished chefs whip

up pastry concoctions, while upstairs Paris-Brests, Mont Blancs, and sought-after tartes au citron are exhibited on marble counter cases. Fine teas and chocolates are also on display, with mirrored walls offering a 360-degree-view of Gaudard's delicacies.

Casting all novelty aside, his forte is tradition, and he trains his team to the highest standard, the way he was taught.

CHRISTOPHE MICHALAK

MICHALAK

If Roald Dahl's *Charlie and the Chocolate Factory* was set in the heart of Paris, it would resemble Christophe Michalak's patisserie. Humour, along with fine chocolates and pastries, of course, are celebrated at Michalak. First rule: Anything containing the letter 'c' is replaced with a 'k', to reference the 'k' in Michalak. Second: Embrace novelty – the 'K7 Audio Chocolate' is an edible cassette, the 'Klakette', a flip-flop-shaped chocolate.

Third: Michalak's chefs are allowed to do everything he wasn't permitted to do while in training to be a chef: for example, sport double-denim and work in a store-level kitchen instead of a basement, with a playlist of nineties songs in the background.

Michalak offers in-store classes, cookbooks, and t-shirts; and he promotes a treat of the day to his 200,000-plus fans, which are usually long gone by end of day.

DINNER OFF THE BEATEN PATH

Farfetch loves a culinary adventure, so we've sought out the world's most expedition-worthy dining destinations. Chefs Blaine Wetzel, Magnus Nilsson, Dan Hunter, and Kobe Desramaults explain how they have transformed their respective specks on the map into must-eat-at destinations.

The four young chefs share an obsessive focus on the often-surprising seasonal and local ingredients from the nearby forests, seas, and farms. A seat at one of their restaurants requires more than simply booking many months in advance – it is the culmination of an adventure for determined diners that may involve flights, rail tickets, long drives, and ferry rides, as well as overnight stays:

Blaine Wetzel foraging for The Willows Inn on Lummi Island.

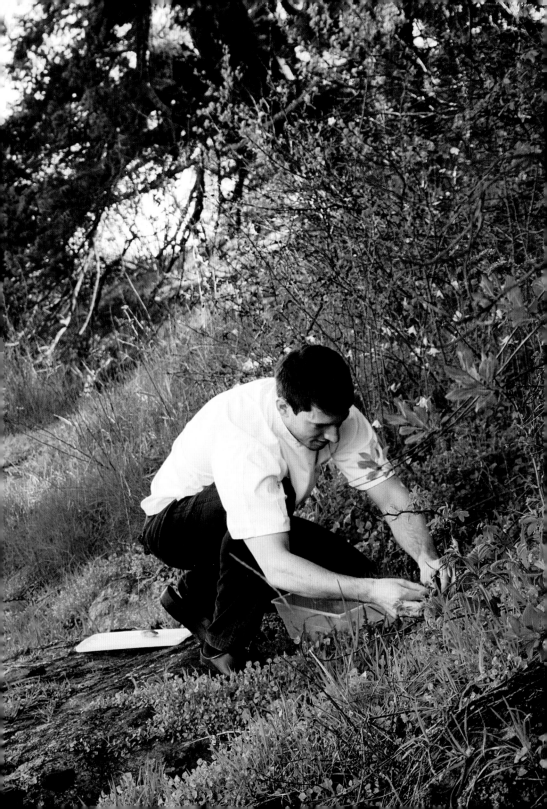

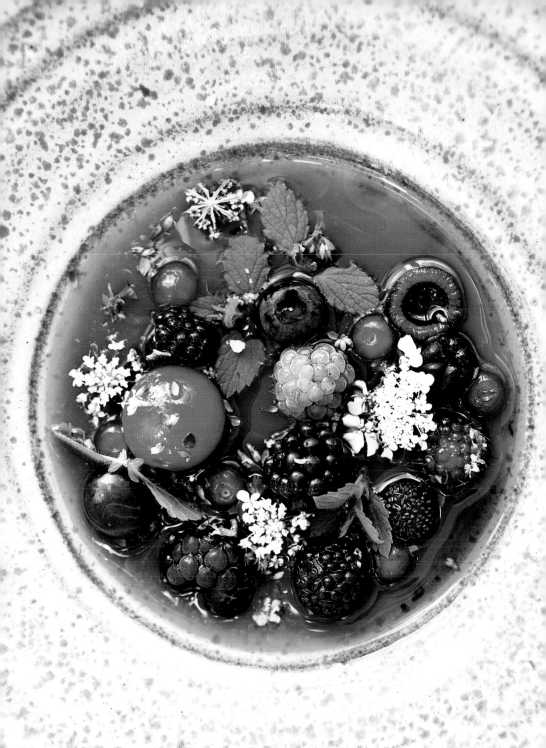

BLAINE WETZEL

THE WILLOWS INN, *Lummi Island, Washington, U.S.*

Blaine Wetzel, a Washington State native, and co-winner of the prestigious James Beard Award for Rising Star Chef of the Year in 2014, replied to a Craigslist posting for the Willows Inn chef opening after working for two years at the esteemed restaurant Noma in Copenhagen. After landing the position, and excited by Lummi Island's possibilities, he returned home in 2009.

The 100-year-old Willows Inn is on Lummi Island, set in Washington State's Puget Sound. The ferry ride from the mainland, Wetzel explains, 'is only about eight minutes long – so you have just enough time to flip into island mode. The natural beauty and wild untouched nature here is incredible, and I like the slower-paced life'.

The eighteen-course tasting menu comprises offerings that are 'here, only now', which requires a continual effort. 'We cook in direct relation to nature, time, and place,' says Wetzel, 'using only ingredients that are freshest and at their peak on the island that day – from bright wild berries in the spring, to the many varieties of mushrooms in the fall, and everything in between.' Though it's hard work for Wetzel, seeing his diners' reactions makes it all worth it.

Wild berries in grass broth.

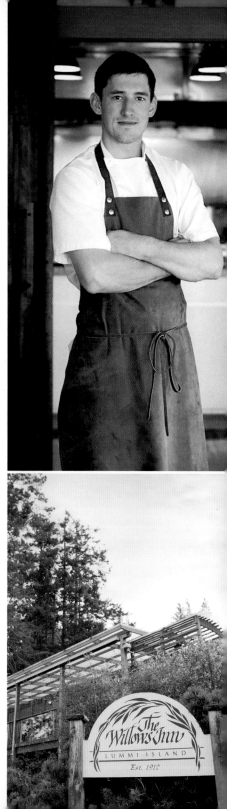

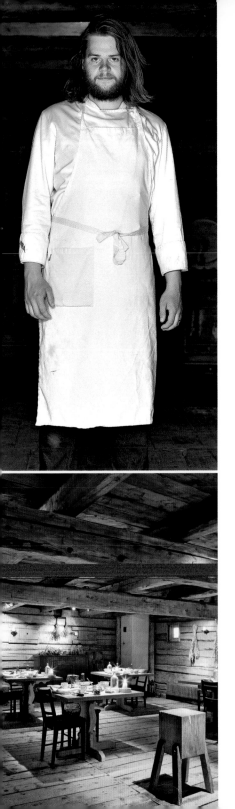

MAGNUS NILSSON

FÄVIKEN MAGASINET, *Järpen, Sweden*

Magnus Nilsson started his culinary education in the cooking school in nearby Åre. By nineteen, he was working at Paris's famed Astrance, where star chef Pascal Barbot instilled in him the importance of working with quality produce.

Fäviken Magasinet, ranked number nineteen in the World's 50 Best Restaurants in 2014, is set on a 24,000-acre hunting estate in northern Sweden, 750 kilometres north of Stockholm. Reaching the twelve-seat restaurant from anywhere outside Sweden requires two flights, via Stockholm, and a ninety-minute drive from the regional capital, Östersund. The lodge's six guest rooms can be booked for overnight stays.

Nilsson and his team fish, hunt, and forage for ingredients that aren't home grown. The lamb comes from Nilsson's own flock of Gotland crossbreeds. Seafood, the only produce from outside of the country, is from the cold, clean waters of Norway's Frøya islands. Much of the cooking is done directly over wood or charcoal fires. Tip: The typical thirteen-course meal starts promptly at 7 p.m. Late arrivals may find locked doors.

i skalet ur elden—scallop cooked over burning juniper branches.

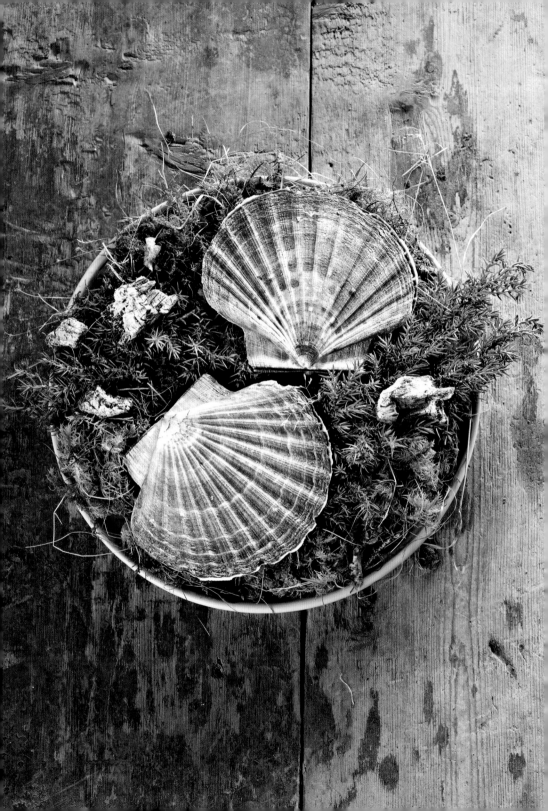

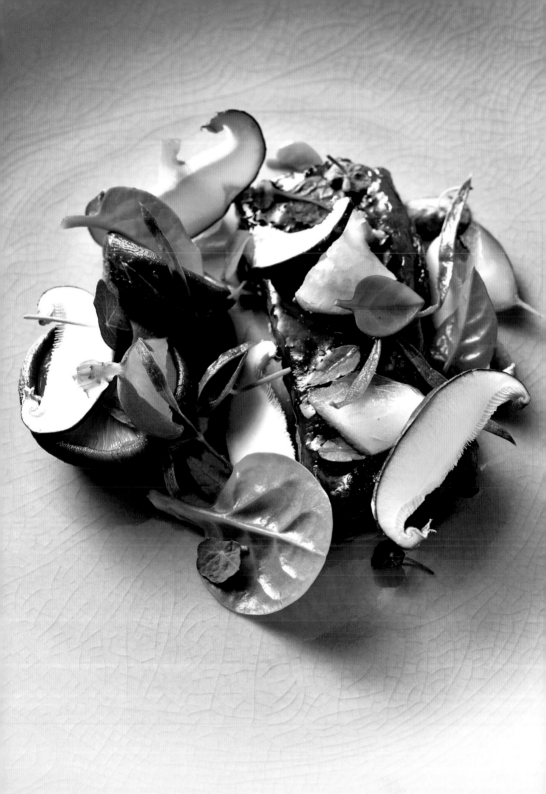

DAN HUNTER

BRAE, *Birregurra, Australia*

Dan Hunter developed his passion for local produce in Spain while working at San Sebastian's renowned Mugaritz. But in his words, he feels 'the most grounded and connected' in Australia. After heading up the Royal Mail Hotel kitchen in Dunkeld, he and his wife, Julianne Bagnato, opened Brae inside a restored 1860s cottage in Birregurra, in 2014.

Arriving in the remote town of Birregurra, with its street of historical shop façades, 'is a bit like stepping back in time', explains Hunter. The tiny town is set in a particularly beautiful area of Australia, ninety minutes from Melbourne, and close to the scenic Great Ocean Road and the Otways rainforest. The region is home to several wineries, olive groves, and sustainable 'pick-your-own' farms.

Brae's menu depends on seasonal produce from the surrounding thirty-acre farm, with its 100-tree olive grove, fifty-tree fruit orchard, kitchen garden, beehives, rolling pastures, and four dams. A highlight of his recent winter menu was an oyster ice cream served in the shell and dusted with sea lettuce, dried oyster, and dried sherry vinegar – 'its deliciousness catches people off guard'.

Salad of grass-fed Wagyu beef, rock samphire, Otway shiitake.

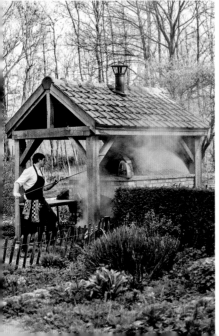

KOBE DESRAMAULTS
IN DE WULF, *Dranouter, Bailleul, Belgium*

After working in restaurants in Spain and the Netherlands, Chef Kobe Desramaults returned home to rural Dranouter to take over his parents' café, In De Wulf. 'I feel such an emotional connection to this land and love the ambience, smells, and beauty,' he says.

Desramaults has noticed that more and more gourmets on 'culinary pilgrimages' are making a stop at his restaurant after exploring the latest offerings in Paris. For those gastro-tourists, reaching In De Wulf from the French capital requires a change of trains in Lille and an eleven-minute taxi ride from the town of Bailleul to the small Flemish village of Dranouter. At In De Wulf, which is set between two hills, Desramaults wants visitors to be able to escape the rest of the world – the ten rooms in the attached accommodation hold guides for exploring nearby towns and fields, but no TVs.

Desramaults and his team rely on mushrooms, berries, and fruits foraged in the hills; produce from local farmers; and fresh seafood from Dunkirk on the nearby French coast. The chef likes to riff on traditional dishes and the specialties of his native Flanders, giving them an experimental new twist.

Oysters from Grevelingen poached and chilled in whey sauce, mustard buds, and flowers.

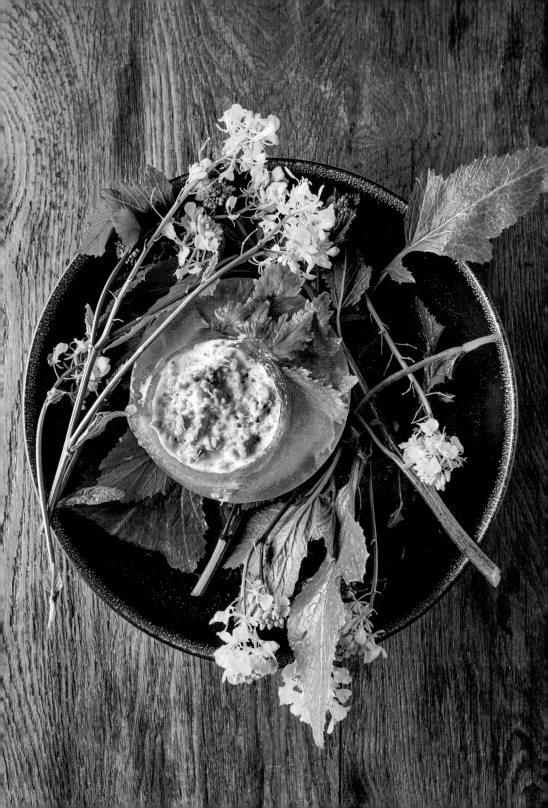

THE NEW FASHION CAPITALS

Fashion weeks are popping up all over the world with new cities emerging as style destinations. But where does the local fashion pack choose to dine and drink during the festivities? We talked directly to the experts in five rising fashion cities:

MOSCOW BY ANYA ZIOUROVA

Fashion Director, Tatler Russia

Moscow Fashion Week is fuelled by champagne. Everyone's drinking it from dawn until dusk. Models and socialites hang out in **Uilliam's,** or **Simachev** wearing Hervé Léger dresses. There is currently a health food craze. Editors convene in the vegetarian restaurant **Fresh** for salads and smoothies. If you want to steer clear of the champagne brigade, you'll be spoiled for choice at **Coffeemania,** a twenty-four-hour no-alcohol restaurant. They serve a popular tea made of yellow berries, soothing for your throat. What I love about the week is the unexpected: You are always looking for the new star.

> **ANYA RECOMMENDS:** **Siberia** for a special midnight meal; **Honest** for a great burger or cupcakes; **Vogue Café** for delectable Russian food – the Buckwheat and Mushrooms is my favourite; and **Magnolia Bakery** for a sweet treat.

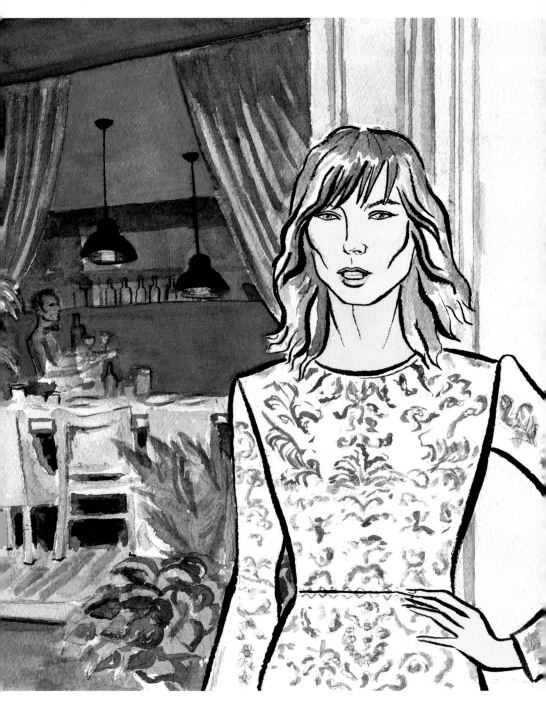

Anya Ziourova recommends a green salad.

COPENHAGEN
BY SILAS ADLER AND
JACOB KAMPP BERLINER

Designers, Soulland

Copenhagen Fashion Week is small, and people tend to support one another. After the shows you'll spot Astrid Andersen, Henrik Vibskov, and Stine Goya swapping stories over cold beers at **Amigo Bar.** Then it's on to **Granola** for oysters and cocktails, or **Condesa** for tacos and margaritas. Copenhagen Fashion Week is very open – it's less about VIP and more about a good vibe, which is why you're more likely to see people eating shawarma and drinking whiskey sours than popping champagne. That's not to say we don't enjoy the finer side of life: If you're lucky enough to get to **Noma,** then you can enjoy the very best food in the world – just be sure to book a year ahead.

SOULLAND RECOMMENDS: **Lidkoeb,** the secret cocktail bar; Christiania, for a hangout by the lake; **Eiffel Bar,** for getting lost; **Aamanns,** for savoury Danish food; and **Central Hotel & Café,** a coffee bar in a tiny one room hotel.

From left: Silas Adler and Jacob Kampp Berliner, Soulland founders, recommend a Smorrebrod sandwich at Aamanns.

Tanja Gacic recommends oysters at Icebergs.

SYDNEY
BY TANJA GACIC
Blogger, My Empirical Life

Sydney Fashion Week is unlike anywhere else. It's a heady mix of sparkling beaches, talented young designers such as Dion Lee, Josh Goot, and Kym Ellery, bustling multicultural vibes, and amazing food. That's a lot to cram into four days! You'll generally find the fashion crowd gathering at **Icebergs** dining room and bar, a gorgeous restaurant with spectacular Bondi Beach vistas, serving the best fresh oysters and Wagyu steak grilled to perfection. **Fratelli Paradiso** is an intimate Italian institution in Potts Point – not even the carb conscious will pass up its delicious pasta with scampi.

> **TANJA RECOMMENDS: Nomad** for homemade wine and cheese and Mediterranean flavours; **Pinbone** for surprising flavour combinations; **Salon de Thé** for delicious French-Vietnamese food; and **Mr. Wong** for the best-ever late-night black pepper crab.

SÃO PAULO
BY JORGE GRIMBERG

Fashion Analyst, Style.com

Brazilians are extremely health conscious, but they can't resist a good pão de queijo (cheese bread ball) and a cafezinho (espresso) to keep up their energy in between shows. The schedule is intense – everyone from Osklen to Alexandre Herchcovitch has to be seen – so there's not much time to relax. After the shows, I head to **Bar da Dona Onça** under the iconic Copan building for food and drinks, or **Numero** for a martini, but the coolest parties always happen after-hours in peoples' houses. If you want to get the best out of São Paulo Fashion Week, you've got to make friends with the right people!

JORGE RECOMMENDS: **Nagayama** for the best sushi; **Spot** restaurant for late-night see-and-be-seen dinner; **B. Bar** in the old city centre for an escape from the fashion crowd; **Chez Mis** or **Mani** for lunch between shows.

Jorge Grimberg recommends a pão de queijo with cafezinho at Chez Mis.

Madame Woo recommends a whiskey at Hopscotch.

SEOUL
BY MADAME WOO

Designer, Wooyoungmi

It's incredible to see so many talented young designers choosing Seoul Fashion Week to show their collections, and using it as a platform to expand their businesses on a global scale. This shift reignited my passion for the industry. Seoul is one of the cultural centres of Asia, which has led to many new international restaurants in the city's main districts. You can enjoy traditional Korean food with a creative twist at **Jungsik,** a contemporary Korean restaurant. Seoul has recently seen a surge of modern whiskey bars opening, such as **Hopscotch,** where you'll find music, great food, and the best selection of whiskeys. But my favourite place to go is **My Allée** – a lifestyle farm owned by my two sisters – where I go after the shows to unwind with a glass of wine and delicious organic food.

> **MADAME WOO RECOMMENDS: Dongdaemun Design Plaza** to see Zaha Hadid's incredible architecture; and a visit to the night markets around the plaza.

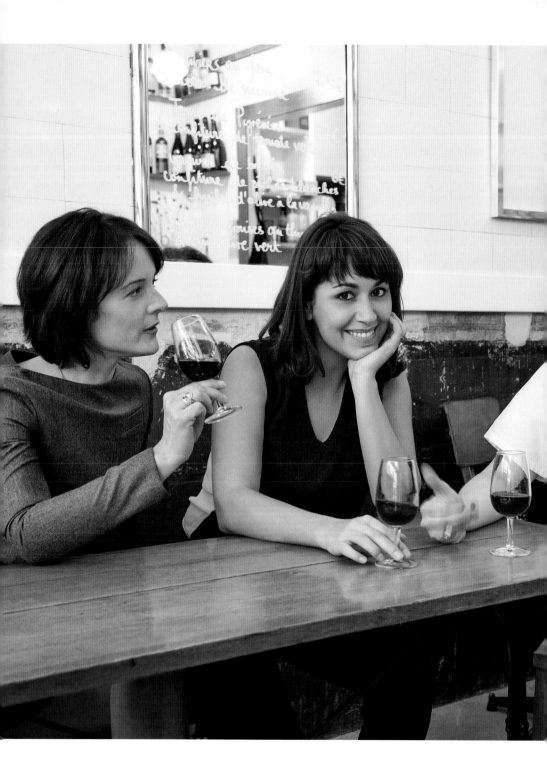

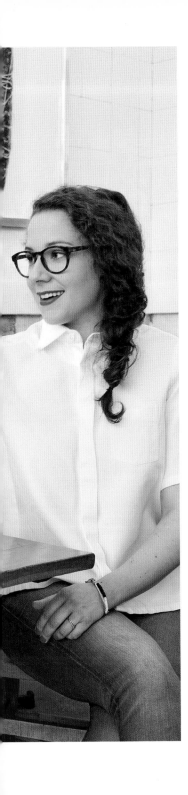

WOMEN IN
WINE

Laura Vidal, Camille Fourmont, and Caroline Loiseleux represent a brilliant new generation of female sommeliers transforming wine cellars across Paris, and they can do more than tell a Pinot Gris from a Pouilly-Fumé. A scenic setting or delicious meal is never complete without a great wine, and these three rising stars reveal their most perfect of pairings:

From left: Caroline Loiseleux, Laura Vidal, and Camille Fourmont.

CAMILLE FOURMONT

WHO: Owner of the relaxed and hip **La Buvette** wine bar in the 11th arrondissement, Fourmont has worked with great chefs such as Chateaubriand's Inaki Aizpitarte.

CAMILLE'S RECOMMENDATIONS FOR:

A SUMMER EVENING: Laurent Saillard Lucky You Sauvignon Blanc – a fresh and crispy white wine with a classic expression of sauvignon called 'bux tree bud'. The wine is straight, but rich and complex at the same time.

A BOOZY BRUNCH: Silvio Morando Bastardo – a lightly sparkling blend of Cortese (white grape) and a tear of red Syrah. This is a cheering wine! It is a beautiful pink colour, very easy to drink, quite light and fruity, with something of a flavour that we call 'sour candy'.

A HEARTY BEEF DINNER: North Côte du Rhône Saint Joseph – a deep fruity expression of mashed black olive, but very soft and not tannic. It's not necessary to drink an overly heavy and structured red wine with meat.

CAROLINE LOISELEUX

WHO: This Montreal native worked with Luca Roagna at Barbaresco winery in Italy before heading to Paris to oversee the wine lists at **Frenchie.**

CAROLINE'S RECOMMENDATIONS FOR:

A FISH SUPPER: A wine that captured my heart this summer is a red from the Canary Islands – Suertes del Marqués 2011 '7 Fuentes', DO Valle de la Orotava, Tenerife. An elegant and refreshing pinot; the nose carries a slight salinity and has a light grilled orange flavour that comes through on the palate.

A DRINK POOLSIDE: Lately I've been stuck on a Tavel rosé 2013 from my friend and producer, Eric Pfifferling. On the nose it showcases vine-ripened peach and English roses. This is a wine that will animate any afternoon, stir up conversation, and will quickly have you ordering another.

A CHOCOLATY DESSERT: Pedro Ximénez of Maestro Sierra. The ripeness of the grape is a beautiful pairing with a chocolate dessert. The acidity of the Ximénez and the seasonal red fruits awaken oil's aromas in the chocolate beans.

LAURA VIDAL

WHO: Known for creating an impressive wine list at Gregory Marchand's acclaimed restaurant Frenchie. She founded Paris Pop-up in 2013, organising a series of restaurants across the world.

LAURA'S RECOMMENDATIONS FOR:

A VEGETARIAN FEAST: Domaine du Collier Saumur Rouge La Charpenterie 2009 – an organic red made from Cabernet Franc with flavours of roasted red peppers, tomatoes, and intense red berries, with bright acidity and a persistent chalky flavour that pairs marvellously with a spicy warm salad.

A CHICKEN ROAST: Jean-Philippe Fichet Puligny-Montrachet 1er Cru Les Referts 2008 – a powerful Chardonnay from Burgundy's Côte de Beaune that has the right balance of toast and zest. This premier cru has a long finish and will stand up to the roast well.

A WINTER EVENING BY THE FIRE: Coliseo VORS from Valdespino. This amontillado is made from a Manzanilla. It ages up to twenty years in Sanlúcar de Barrameda in southern Spain and then for a further sixty in Jerez – a pure essence of nutty acidity and salinity.

Laura Vidal.

A VEGETARIAN IN TOKYO

'Does fish count as vegetarian?' Yasuko Furuta, the designer behind cult Japanese label Toga, hears this question from waiters more often than she'd like. But, as a vegetarian in Tokyo – a city with 1,000 rules on how to slice salmon, and where one bluefin tuna can fetch £174K – she has become used to it. Furuta reveals to Farfetch the greatest places in the city for picking up a meat-free feast:

The fashion world gets a bad rap for its fastidious eating rituals, but as Japan's influence as a fashion capital grows ever greater, hordes of models, stylists, and editors have found themselves navigating a staunchly anti-herbivorous food landscape. Stylist Anna Trevelyan travels to Tokyo frequently for work and finds herself constantly decoding her diet for serving staff: 'Even if people understand you are vegetarian, they often think fish is okay for you, which it isn't. And since almost all noodles and rice are cooked in fish-based stock, it's a constant battle to break down the lingual and gastronomic barriers.'

Yasuko Furuta in Pure Café.

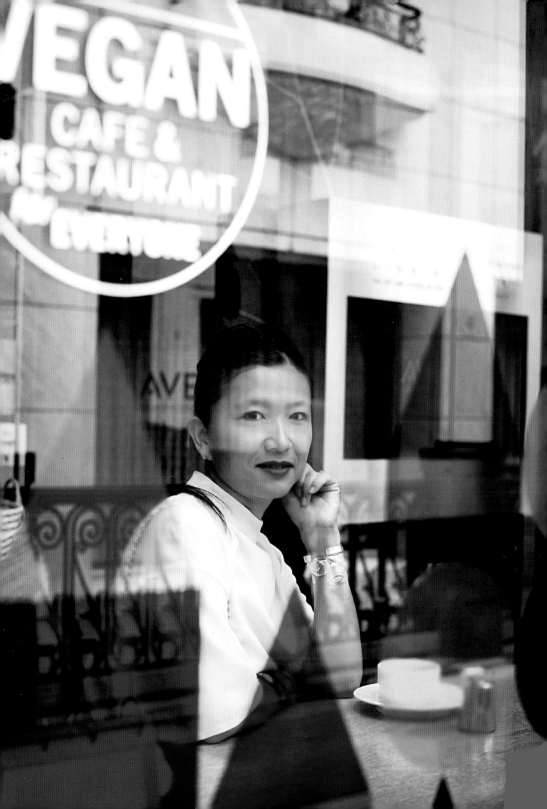

The confusion is hardly surprising – the Japanese diet is one of the healthiest in the world. It's well documented that Japanese men and women live an average of 4.5 years longer than their Western counterparts, and the obesity rate is the lowest in the world. But just because it's a nutritionist's utopia doesn't mean that the diet is one-size-fits-all.

Furuta employs the same approach to her diet as she does to her clothing collections: deconstruction, challenging the status quo, and elimination of effluence in order to 'produce new ideas which will become future standards'.

Raised on a healthy Japanese diet of meat, fish, and the Buddhist-originated vegetarian cuisine known as Shojin Ryori, Furuta decided to become a vegetarian after experimentation with fasting led her to be more in tune with her body. But there's a darker issue at play too: After the catastrophic earthquake of March 2011, the Japanese government's censorship of information about the country's radiation levels following the Fukushima explosion gave rise to a nationwide suspicion of food safety standards. 'After 3/11, it's become important for many Japanese people to

Vegetable Holic from Pure Café. *Opposite*: Yasuko Furuta shops in Pure Café.

carefully consider where food comes from and how it is produced,' explains Furuta. 'This has meant being sceptical of the information the government and profit-driven chain stores provide. Independent research and selection has become crucial.'

With production for her label taking place in Europe, and Toga now on the show schedule at London Fashion Week, Furuta is travelling back and forth to the U.K. for work and finds the contrast stark in terms of options available to her. 'In Japan, the only things you can rely on being vegetarian are soba or tempura, but in Europe you can go anywhere without having to worry about asking twenty questions about every dish.'

But the appeal of a bold 'V' sign on a menu isn't enough to lure Furuta away from Tokyo. Fashion, of course, wins out. 'It's said that Japan has as many fashion stores as all of Europe. That, coupled with the exchange of ideas with China and Korea, makes it a really exciting place to be for fashion right now.'

And judging by the boundary-pushing fashion coming out of Furuta's studio, firing off questions about fish stock seems a small price to pay for being a part of one of the most exciting fashion cities on earth.

YASUKO'S TOKYO VEGETARIAN RECOMMENDATIONS

PURE CAFÉ IN MINATO: My favourite place to go for vegetarian food – breakfast, lunch, and dinner.

DHABA INDIA IN GINZA: Delicious South Indian flavours, and my favourite place for curry in Tokyo.

NAGI SHOKUDO IN SHIBUYA: Fantastic vegan food. The lunch deal is exactly what you want.

ALASKA IN NAKAMEGURO: A cute vegan restaurant with a retro vibe and simple, audacious salads.

TURANDOT IN AKASAKA: Healthy Chinese food from a Japanese chef.

ICONIC COCKTAILS

Everyone loves a cocktail. But how many of us know the stories behind the names that grace cocktail lists around the globe? Here, BarChick – an online reviewer of the best bars and the newest dalliances in drinking – gives Farfetch a short history of the world's most famous, and infamous, mixes:

TOMMY'S MARGARITA

TOMMY'S BAR, *San Francisco, California, U.S.*

In a tiny San Franciscan bar attached to a Mexican restaurant, Julio Bermejo, the manager of Tommy's Bar, took a classic party drink to the next level by creating the low-cal Tommy's Margarita. The secret's not what's in it, but more what's *not* in it – sugar, sour mix, and triple sec are out and are replaced with fresh limes and reposado tequila.

PICKLEBACK

BUSHWICK COUNTRY CLUB,
Brooklyn, New York, U.S.

Now a worldwide dive-bar staple, the original is still on the menu at the place credited with inventing it. Brooklyn's hipster-filled Bushwick Country Club serves a shot of Jameson Irish whiskey alongside a chaser of McClure's spicy pickle brine. Perfect simplicity!

SIDECAR

HARRY'S BAR, *Paris, France*
Many people might not be aware of the backstory of this classic drink. The story goes that an American army captain first requested this heady concoction of brandy, triple sec, and lemon juice in the 1920s. He swiftly knocked it back and disappeared into the narrow streets of Paris in the sidecar of a motorcycle. Nothing is as chic as lounging in Harry's Bar with one in hand after a day at the shows.

ESPRESSO
MARTINI

EL CAMION'S BAJA ROOM,

London, U.K.

Underneath a sex shop in
Soho's El Camion bar, Dick
Bradsell created the espresso
martini for a very famous 90s
model who asked for a drink
that would 'wake me up and
f*ck me up'. His combination
of vodka, coffee liqueur, and
espresso does exactly that!

WHITE LADY

AMERICAN BAR AT THE SAVOY,

London, U.K.

In the 1930s, the legendary Harry Craddock created this signature gin cocktail at The Savoy. Its guests are as famous as its views. Sinatra used to sneak in after-hours to play the piano, and Elizabeth Taylor met up with Richard Burton in the restaurant. Enough said.

HEALTHY MEASURES

THE BEETROOT MARY

THE BOTANIST, *London, U.K.*

The Beetroot Mary was created in 2013 when The Botanist was looking at ways of injecting delicious yet healthy options into its cocktail offering. Beetroot is a superfood and contributes to increased stamina and lower blood pressure, with added benefits when you combine it with the aperitif Kamm & Sons. The main ingredient in Kamm & Sons is ginseng, which both increases blood flow and improves general vitality. Other ingredients include Manuka honey, with its anti-viral qualities, goji berries, packed full of antioxidants, and echinacea, chosen for boosting the immune system.

VS. GUILTY PLEASURES

Farfetch's favourite after-dinner cocktails

THE JOSEPHINE BAKER

NIGHTJAR, *London, U.K.*

This cocktail is adapted from an original recipe that first appeared in the book *Bar La Florida Cocktails,* published in Havana, Cuba, in 1935. This deliciously decadent flip-style tipple is named after the famous 1920s vaudevillian dancer, singer, and actress Josephine Baker. Her namesake cocktail reflects her titillating spirit and is forged from a mixture of Ysabel Regina brandy, Pedro Ximénez sherry, and Tonka bean liqueur, combined with passion fruit curd for a thick, frothy texture. This complex drink – sweet, creamy, and tangy – is the perfect late-night indulgence.

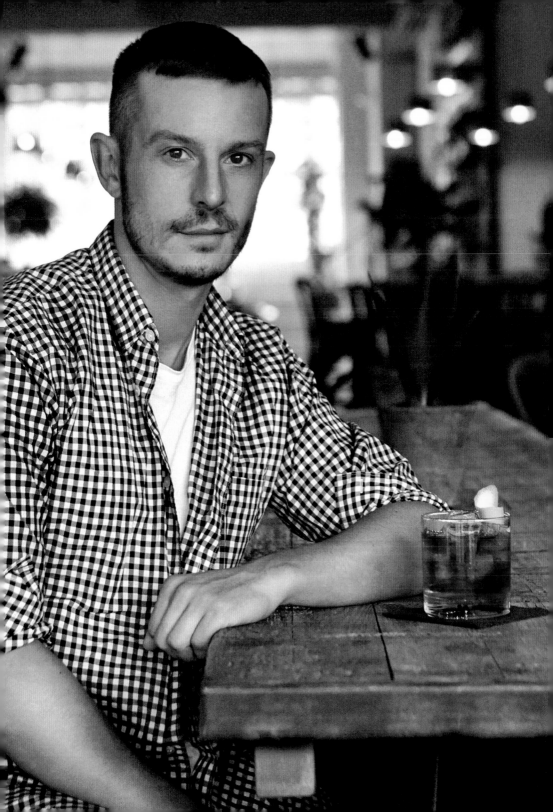

WINDING DOWN WITH JONATHAN SAUNDERS

After a long day in the studio, London-based fashion designer Jonathan Saunders likes nothing better than unwinding with cocktail in hand. In his favourite East End eatery he explains why when the evening draws in, there's nowhere else he'd rather be:

THE LAUNDRY IS MY PERFECT AFTER-WORK SPOT BECAUSE: It's cool, the drinks are good, the food is great, and best of all, it's just around the corner from my studio.

THERE'S ALWAYS SOMEONE TO HAVE A DRINK WITH: Many of my friends – Christopher Kane, Roksanda Ilincic, Richard Nicoll, Peter Pilotto – have studios nearby, so you're bound to run into someone.

BUT I ALSO LOVE TO COME HERE ALONE: Often when you're a fashion designer, you are continually working with a team of people – discussing, answering questions, delegating – so during work hours you often don't get much time to actually be creative. I like to escape to here because it's somewhere I can find space to think.

MY FAVOURITE SEAT IN THE HOUSE IS: In the back, with quick access to the smoking area. I'm trying to give up, but the problem is, I just don't want to.

THE FIRST THING I ORDER IS: A Negroni.

MY FAVOURITE DISH IS: The pork belly – it's unreal. Last time I came here with the team, we just kept ordering it until they ran out.

MY GUILTY PLEASURE IS: Really strong cheese.

I CAN NEVER RESIST: The bread basket, with lashings of olive oil. I'm usually full by the time the food arrives.

THE THING I LOOK FORWARD TO MOST AT THE END OF THE DAY IS: Coming here and chilling with my dog, Amber, a Staffy who is twelve years old. She's still in great shape, but she's starting to go a bit grey around the face. I might dye it.

THE INGREDIENTS TO A PERFECT EVENING OUT ARE: A successful day at work, friends you can really relax with, and sunbeams through the windows.

Jonathan Saunders in The Laundry.

FARFETCH DISCOVER

Farfetch boutique owners recommend some of their favourite local haunts for eating and drinking.
For more recommendations, go to the Farfetch Discover app.

FRANCE

Lyon

CAPSULE BY ESO RECOMMENDS:
BERNACHON
Bernachon makes world-renowned chocolates and sublime cakes. The shop also has a café, where you can try their pastries.

COMPTOIR DE LA BOURSE
Located just next to our boutique, Comptoir de la Bourse is a sophisticated lounge bar, quiet in the morning and lively in the evenings. It has a smart clientele and trendy electro background music.

TÊTEDOIE
This restaurant is beautifully designed and has a renowned chef and gourmet cuisine, but it's the terrace, with its panoramic views of the city, that's the main attraction here.

Paris

BIONDINI RECOMMENDS:
RALPH'S
This is the restaurant attached to fashion label Ralph Lauren. It offers a vegetarian menu and a delightful courtyard to dine in during the summer season.

BOUTIQUE 58M RECOMMENDS:
LE PERCHOIR
One of our good friends opened this restaurant. It's a very secret place with a unique menu and also has the best and most surprising view of Paris.

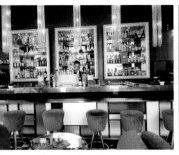
Comptoir de la Bourse.

Têtedoie.

Bernachon.

ITALY

Florence

SOCIÉTÉ ANONYME RECOMMENDS:

BRAC

For exceptional vegan and vegetarian dishes, make sure you check out Brac. The food is presented to perfection and tastes absolutely delicious! We're always happy to dine here for lunch or dinner while perusing their selection of contemporary art books and magazines.

Milan

WOK-STORE RECOMMENDS:

CARLO E CAMILLA IN SEGHERIA

Carlo Cracco, Tanja Solci, and Nicola Fanti give new life to an old sawmill in the heart of Milan, where they have created a cocktail bar and restaurant par excellence.

Pisa

DIVO RECOMMENDS:

AMEDEI

Amedei is one of the most important chocolate producers in the world. The factory is a magical place where hands are busy creating chocolate works of art and happiness lingers.

Rome

GENTE ROMA RECOMMENDS:

STRAVINSKIJ BAR

Intimate and exclusive, the Stravinskij Bar is a flagship for the noted Hotel de Russie. It is the perfect place to enjoy an excellent cocktail while soaking up the fresh air and sunlight in a heavenly garden.

Siena

DOLCI TRAME RECOMMENDS:

IL MAGNIFICO

Head to Il Magnifico to try local delicacies such as panforte and pane co' santi that are made using the traditional recipes.

Carlo e Camilla.

Brac.

Stravinskij Bar.

PORTUGAL

Cascais

ESPACE CANNELLE RECOMMENDS:

FURNAS DO GUINCHO

Dine al fresco at one of the best seafood restaurants on the Estoril coast while admiring the stunning views of the Tagus River and the Atlantic Ocean.

HOTEL BAÍA'S BLUE BAR

Soak up the last rays of the day at Blue Bar's poolside terrace, on the roof of Hotel Baía Cascais and overlooking the ocean, while sipping fresh cocktails and enjoying music from local DJs.

Lisbon

FASHION CLINIC RECOMMENDS:

BELCANTO

At the Michelin-starred Belcanto, chef José Avillez offers a modern take on Portuguese cuisine. An absolute must is the Skate Jackson Pollock, a seafood dish that is as visually stimulating as it is delicious.

STIVALI RECOMMENDS:

ALTIS AVENIDA HOTEL ROOFTOP

Indulge in one of the bar's fruity cocktails while looking out to the busy Avenida da Liberdade, the most luxurious avenue in the city.

Altis Avenida Hotel Rooftop.

Belcanto.

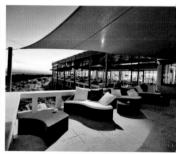
Furnas Do Guincho.

SPAIN

Barcelona

PAOLA RECOMMENDS:
MONVÍNIC

With a white and stainless-steel interior, Monvínic is a wonderfully modern restaurant. Despite its busy moments, it always maintains a calm and relaxing ambience. Chefs serve up a broad selection of meals, such as quiche, sardines with fresh anchovies, and a caramelised shank of roast beef.

Madrid

GALLERY MADRID RECOMMENDS:
RAMSES

The only way to describe a night out at Ramses is 'cosmopolitan meets innovation'. French designer Philippe Starck put his signature touch on this bar/restaurant, with its graffiti walls and baroque influence.

RESTAURANTE ÁLBORA

If you love Spanish-style haute cuisine, then head to Restaurante Álbora in the Salamanca district of Madrid. Here you can enjoy the finest food, from oysters to roasted lobster, with a fresh and experimental twist. It's a great option for a spot of tapas too – there's a seated bar area that's ideal for a quick bite with friends.

GALLERY PLUS RECOMMENDS:
RESTAURANTE EL COCINILLAS

Cocinillas is located in the heart of Madrid. As its slogan 'between tradition and innovation' states, the restaurant finds the right balance between authentic Spanish recipes and modern ingredients to create a wonderful dining experience.

Marbella

ELITE RECOMMENDS:
EL GRAN GATSBY

This restaurant offers fantastic service and food (try the Tartar de Atún!) and unbeatable views of Puerto Banús.

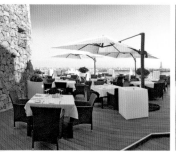

El Gran Gatsby.

Ramses.

Monvínic.

UNITED KINGDOM

London

FEATHERS RECOMMENDS:
MANUKA KITCHEN

This is the place to go for Sunday brunch. It's small and cosy, with an amazing selection of hearty food and a relaxed atmosphere.

GENEVIEVE RECOMMENDS:
THE LEDBURY

This restaurant is in a league of its own. Brett Graham, the modest Australian chef, never fails to impress with his exquisite yet simple dishes.

PRESS RECOMMENDS:
DRINK, SHOP & DO

If you really want to have a good time in London, visit Drink, Shop & Do. Here you can enjoy coffee and cake, take part in an arts and crafts class, and then dance the night away.

REWIND VINTAGE AFFAIRS RECOMMENDS:
OLIVOMARE

This Sardinian restaurant in Belgravia serves sea urchin crostini and pasta alla bottarga to die for. Expect sleek, modern surroundings, and no-fuss food that you can usually only get in an Italian home.

SEFTON MEN RECOMMENDS:
RUBY'S

Don't leave London without trying some of the best cocktails in town. Ruby's in Stoke Newington is an underground bar with a wicked atmosphere and exceptional service. We love the extra-special touch of serving blackberry mojitos in vintage 1940s milk bottles.

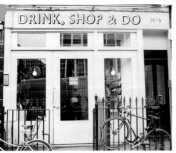

Drink, Shop & Do.

Ruby's.

Olivomare.

UNITED STATES

Culver City, California

CURVE RECOMMENDS:

AKASHA

We love Akasha restaurant. They serve the most wonderful rustic American dishes, and the neighbourhood has such a youthful vibe, too – the perfect hangout.

Chicago, Illinois

GALLERY AESTHETE RECOMMENDS:

LONGMAN & EAGLE

At Longman & Eagle, chef Jared Wentworth is famed for making traditional American dishes sourced from the finest local ingredients. If that's not enough to entice you, the restaurant's extensive beer and cocktail list certainly will!

Dallas, Texas

FORTY FIVE TEN RECOMMENDS:

MR MESERO

For amazing Mexican food, check out Mr Mesero, which mixes American and Mexican cuisine. The tacos are best enjoyed with a delicious hot dog.

Seattle, Washington

DAVID LAWRENCE RECOMMENDS:

CHATEAU STE. MICHELLE IN WOODINVILLE

Washington State's most acclaimed winery hosts lots of memorable events, including summer concerts, wine tastings, and culinary experiences.

JOHN HOWIE STEAK

From comfort food to fancy food to six tiers of the world's best steaks and signature cocktails at easy prices – this is one of our favourite restaurants.

Akasha.

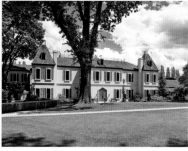
Chateau Ste. Michelle.

Longman & Eagle.

FARFETCH DIRECTORY

AUSTRALIA

BRAE
4285 Cape Otway Rd
Birregurra
Victoria 3242
Tel: +61 3 5236 2226
braerestaurant.com

FRATELLI PARADISO
12-16 Challis Ave
Potts Point
New South Wales 2011
Tel: +61 2 9357 1744
fratelliparadiso.com

ICEBERGS
One Notts Avenue
Bondi Beach
New South Wales 2026
Tel: +61 2 9365 9000
idrb.com

MR. WONG
3 Bridge St
Sydney
New South Wales 2000
Tel: +61 2 9240 3000
merivale.com.au/mrwong

NOMAD
16 Foster St
Surry Hills
New South Wales 2010
Tel: +61 2 9280 3395
restaurantnomad.com.au

PINBONE
3 Jersey Rd
Woollahra
New South Wales 2025
Tel: +61 2 9328 1600
pinbone.com.au

SALON DE THÉ
225 Victoria St
Darlinghurst
New South Wales 2011
Tel: +61 2 8040 6817
salondethe.com.au

BELGIUM

■ **THE BOWERY & S-Bar**
at SMETS
Premium Store Brussels
Chaussée de Louvain 650-652
1030 Schaerbeek
Tel: +32 2 325 12 90
bowery.be

IN DE WULF
Wulvestraat 1
8951 Heuvelland
Tel: +32 57 44 55 67
indewulf.be

■ **IRINA KHÄ**
Rue du Pot d'Or 12
4000 Liege
Tel: +32 4 221 21 35
irina-kha.com

■ **RENAISSANCE**
Nationalestraat 32
2000 Antwerp
Tel: +32 3 369 01 08
resto-renaissance.be

BRAZIL

B. BAR
Alameda Jaú, 1565
Jardim Paulista, São Paulo
Tel: +55 11 3064 1699

BAR DA DONA ONÇA
Edifício Copan
Avenida Ipiranga, 200
República, São Paulo
Tel: +55 11 3257 2016
bardadonaonca.com.br

CHEZ MIS
Avenida Europa, 158
Jardim Europa, São Paulo
Tel: +55 11 3467 3441
chezmis.com.br

MANI
Rua Joaquim Antunes, 210
Jardim Paulistano, São Paulo
Tel: +55 11 3085 4148
manimanioca.com.br

NAGAYAMA
Rua da Consolação, 3397
Jardins, São Paulo
Tel: +55 11 3064 0110
www.nagayama.com.br

NUMERO
Rua da Consolação, 3585
Jardins, São Paulo
Tel: +55 11 3061 3995
barnumero.com.br

SPOT
Alameda Ministro Rocha
Azevedo, 72
Bela Vista, São Paulo
Tel: +55 11 3283 0946
restaurantespot.com.br

DENMARK

AAMANNS
Øster Farimagsgade 10
2100 Copenhagen Ø
Tel: +45 35 55 33 44
aamanns.dk

AMIGO BAR
Schønbergsgade 4
1906 Frederiksberg C
Tel: +45 33 21 49 15

CENTRAL HOTEL & CAFÉ
Tullinsgade 1
1610 Copenhagen V
Tel: +45 33 21 00 95
centralhotelogcafe.dk

CONDESA
Ved Straden 18
1061 Copenhagen K
Tel: +45 33 91 74 00
condesa.dk

EIFFEL BAR
Wildersgade 58
1408 Copenhagen K
Tel: +45 32 57 70 92
eiffelbar.dk

GRANOLA
Værnedamsvej 5
1819 Frederiksberg C
Tel: +45 32 25 00 80
granola.dk

■ **HENRIK VIBSKOV
BOUTIQUE**
Krystalgade 6
1172 Copenhagen
Tel: +45 33 14 61 00
henrikvibskov.com

KAFFEBAR
Elmegade 4
2200 Copenhagen N
Tel: +45 35 35 30 38
elmegade4.dk

LIDKOEB
Vesterbrogade 72B
1620 Copenhagen V
Tel: +45 33 11 20 10
lidkoeb.dk

NOMA
Strandgade 93
1401 Copenhagen K
Tel: +45 32 96 32 97
noma.dk

FRANCE

BERNACHON
42 Cours Franklin Roosevelt
69006 Lyon
Tel: +33 4 78 24 37 98
bernachon.com

■ **BIONDINI**
78 Avenue des
Champs-Elysées
75008 Paris
Tel: +33 1 43 59 11 59
biondiniparis.com

■ **BOUTIQUE 58M**
58 rue Montmartre
75002 Paris
Tel: +33 1 40 26 61 01
58m.fr

LA BUVETTE
67 rue Saint-Maur
75011 Paris
Tel: +33 9 83 56 94 11

■ **CAPSULE BY ESO**
21 rue Gentil
69002 Lyon
Tel: +33 4 78 91 17 85
capsulebyeso.com

COMPTOIR DE LA BOURSE
33 rue de la Bourse
69002 Lyon
Tel: +33 4 72 41 71 52
comptoirdelabourse.fr

L'ÉCLAIR DE GÉNIE
14 rue Pavée
75004 Paris
Tel: +33 1 42 77 85 11
leclairdegenie.com

FRENCHIE
5-6 rue du Nil
75002 Paris
Tel: +33 1 40 39 96 19
frenchie-restaurant.com

HARRY'S BAR
5 rue Daunou
75002 Paris
Tel: +33 1 42 61 71 14
harrysbar.fr

MICHALAK
60 rue du Faubourg
Poissonnière
75010 Paris
Tel: +33 1 42 46 10 45
christophemichalak.com

LE PERCHOIR
14 rue Crespin du Gast
75011 Paris
Tel: +33 1 48 06 18 48
leperchoir.fr

FARFETCH DIRECTORY

RALPH'S
173 Boulevard Saint-
Germain
75006 Paris
Tel: +33 1 44 77 76 00
ralphlaurenstgermain.com

SÉBASTIEN GAUDARD
22 rue des Martyrs
75009 Paris
Tel: + 33 1 71 18 24 70
sebastiengaudard.fr

TÊTEDOIE
Montée du Chemin Neuf
69005 Lyn
Tel: +33 4 78 29 40 10
tetedoie.com

GERMANY

PAPER & TEA
Bleibtreustraße 4
10623 Berlin
Tel: +49 30 555 798 071
paperandtea.com

INDIA

KAILASH PARBAT
Food Court
Main Line, Mumbai Central
Station
Bellasis Road
Mumbai 400 008
Tel: +91 22 23063650
kailashparbat.in

KONKAN CAFÉ
Vivanta by Taj Hotel
90 GD Somani Rd
Chamundeshwari Nagar
Cuffe Parade
Mumbai 400 005
Tel: +91 22 66650808
vivantabytaj.com

■ **LE MILL BOUTIQUE**
2 Meherabad
Warden Road
Breach Candy
Mumbai 400 036
Tel: +91 22 23684461
lemillindia.com

ITALY

AMEDEI
Via San Gervasio, 29
56025 Pontedera (Pisa)
Tel: +39 0587 484849
amedei.it

■ **LA BARONESSA**
Corso Umberto 1, 148
98039 Taormina (Messina)
Tel: +39 0942 628191
ristorantebaronessa.it

BRAC
Via dei Vagellai, 18R
50122 Florence
Tel: +39 055 0944877
libreriabrac.net

**CARLO E CAMILLA IN
SEGHERIA**
Via G. Meda, 24
20141 Milan
Tel: +39 02 8373963
carloecamillainsegheria.it

■ **DIVO**
Via Bientina, 64
56020 Santa Maria a
Monte (Pisa)
Tel: +39 0587 707130
divo.it

■ **DOLCI TRAME**
Via del Moro, 4
53100 Siena
Tel: +39 0577 46168
dolcitrame.it

■ **GENTE ROMA**
Via del Babuino, 185
00187 Rome
Tel: +39 06 3225954
genteroma.com

IL MAGNIFICO
Via dei Pellegrini, 27
53100 Siena
Tel: +39 0577 281106
ilmagnifico.siena.it

■ **PARISI**
Corso Umberto 1, 170
98039 Taormina (Messina)
Tel: +39 0942 23151
parisitaormina.com

■ **SOCIÉTÉ ANONYME**
Via Niccolini, 3F - Ang Via
della Mattonaia
50121 Florence
Tel: +39 055 3860084
societeanonyme.it

STRAVINSKIJ BAR
Via del Babuino, 9
00187 Rome
Tel: +39 06 32888874
hotelderussie.it

■ **WOK-STORE**
Viale Col di Lana, 5/a
20136 Milan
Tel: +39 02 89829700
wok-store.com

JAPAN

ALASKA
2-5-7 Higashiyama
Meguro-ku, Tokyo
Tel: +81 3 6425 7399
alaskaswimclub.com

DHABA INDIA
Sagami bld 1F 2-7-9 Yaesu
Chuo-ku, Tokyo
Tel: +81 3 3272 7160
dhabaindia.com

NAGI SHOKUDO
15-10 Uguisudanicho
Shibuya-ku, Tokyo
Tel: +81 050 1043 7751
nagishokudo.com

PURE CAFÉ
5-5-21 Minamiaoyama
Minato-ku, Tokyo
Tel: +81 3 5466 2611
pure-cafe.com

TURANDOT
6-16-10 Akasaka
Minato-ku, Tokyo
Tel: +81 3 3568 7190

KOREA

HOPSCOTCH
113-20 Nonhyeon-dong
Gangnam-gu, Seoul
Tel: +82 2 511 0145

JUNGSIK
649-7 Sinsa-dong
Gangnamgu, Seoul
Tel: +82 2 517 4654
jungsik.kr

MY ALLÉE
434-3 Juam-dong
Gwacheon-si, Gyeonggi-do
Tel: +82 2 3445 1794
myallee.co.kr

NORWAY

TIM WENDELBOE
Grüners gate 1
0552 Oslo
Tel: +47 40 00 40 62
timwendelboe.no

POLAND

■ **CONCEPT 13** at VITKAC
Bracka 9
00-501 Warsaw
Tel: +48 22 310 73 13
vitkac.com

PORTUGAL

**ALTIS AVENIDA HOTEL
ROOFTOP**
Rua 1 Dezembro, 120
1200-360 Lisbon
Tel: +351 21 04 40 008
altishotels.com

BELCANTO
Largo de São Carlos, 10
1200-410 Lisbon
Tel: +351 21 34 20 607
belcanto.pt

BLUE BAR
Hotel Baía
Avenida Marginal
2754-509 Cascais
Tel: +351 214 831 033
hotelbaia.com

■ **ESPACE CANNELLE**
Arcadas do Parque, 52H
Avenida Clotilde
2765-211 Estoril
Tel: +351 214 662 141
espacecannelle.com

■ **FASHION CLINIC**
Avenida da Liberdade, 180
1250-146 Lisbon
Tel: +351 21 31 45 397
fashionclinic.pt

FURNAS DO GUINCHO
Avenida Nossa Senhora do
Cabo, 1265
2750-642 Cascais
Tel: +351 214 869 243
furnasdoguincho.pt

■ **STIVALI**
Avenida da Liberdade, 38B
1250-145 Lisbon
Tel: +351 21 38 05 110
stivali.pt

RUSSIA

COFFEEMANIA
Malyy Cherkasskiy pereulok, 2
Moscow 109012
Tel: +7 495 960 22 95
coffeemania.ru

FARFETCH DIRECTORY

FRESH
Ulitsa Bolshaya Dmitrovka, 11
Moscow 125009
Tel: +7 965 278 90 89
freshrestaurant.ru

HONEST
Stoleshnikov Lane, 10/3
Moscow 125009
Tel: +7 499 678 01 60

MAGNOLIA BAKERY
Kuznetsk Bridge, 18/7,
Bldg 1
Moscow 107031
Tel: +7 495 642 64 43
magnoliabakery.com/
moscow

SIBERIA
Bolshaya Nikitskaya, 58
Moscow 121069
Tel: +7 495 695 36 95
siberiamoscow.ru

SIMACHEV
Stoleshnikov preulok, 12/2
Moscow 103031
Tel: +7 495 629 5702
denissimachev.com

UILLIAM'S
Malaya Bronnaya ulitsa, 20a
123104 Moscow
Tel: +7 495 650 64 62
oneforocean.com

VOGUE CAFÉ
Kuznetsk Bridge, 7/9
Moscow 107031
Tel: +7 495 623 1701
condenastinternational
restaurants.com

SINGAPORE

**545 WHAMPOA
PRAWN NOODLES**
Tekka Centre
665 Buffalo Road, #01-326
Singapore 210665

ALIBABAR
125 East Coast Road
Singapore 428810
Tel: +65 6440 6147

ARTICHOKE
Middle Road, 161
Sculpture Square
Singapore 188978
Tel: +65 6336 6949
artichoke.com.sg

BUKIT MERAH HAWKERS
Blk 119 Bukit Merah Lane
1, #01-40
Singapore 151119

**BROWN SUGAR
BY ESKIMO**
Tel: +65 6273 1865

**IMMANUEL FRENCH
KITCHEN**
Tel: +65 9297 3285

**MIÀN BY THE
TRAVELLING C.O.W**
Tel: +65 9818 6636
thetravellingcow.com

SALUTE

STEW KÜCHE
Tel: +65 6276 6445

TWO WINGS
Tel: +65 9667 0368
twowings.com.sg

FISHBALL STORY
505 Beach Road, #01-85
Singapore 199583
Tel: +65 9800 5036

SPAIN

ÁLBORA
Calle de Jorge Juan, 33
28001 Madrid
Tel: +34 91 781 61 97
restaurantealbora.com

CHURRERIA RAMON
Plaza de los Naranjos
29601 Marbella
Tel: +34 952 77 85 46
churreriaramon.com

EL COCINILLAS
Calle de San Joaquín, 3
28004 Madrid
Tel: +34 91 523 29 60
restauranteelcocinillas.com

■ **ELITE BOUTIQUE**
Conjunto Benabolá, 8
29660 Puerto Banús
Tel: +34 952 81 26 21
elitestore.es

■ **GALLERY MADRID**
Calle de Jorge Juan, 38
28001 Madrid
Tel: +34 915 76 79 31
gallerymadrid.com

EL GRAN GATSBY
Edificio del Mar, Muelle de
Honor
29660 Marbella
Tel: +34 951 77 87 97
elgrangatsby.com

MONVÍNIC
Carrer de la Diputació, 249
08007 Barcelona
Tel: +34 932 72 61 87
monvinic.com

■ **PAOLA**
Carrer de Fernando
Agulló, 8
08021 Barcelona
Tel: +34 932 092 723
paola-boutique.com

RAMSES
Plaza de la Independencia, 4
28001 Madrid
Tel: +34 91 435 16 66
ramseslife.com

SWEDEN

FÄVIKEN MAGASINET
Fäviken 216
830 05 Järpen
Tel: +46 647 401 77
favikenmagasinet.se

U.K.

AMERICAN BAR
The Savoy
Strand
Savoy Way
London WC2R 0EU
Tel: + 44 20 7836 4343
fairmont.com/savoy-london

THE BOTANIST
7 Sloane Square
London SW1W 8EE
Tel: +44 20 7730 0077
thebotanistonsloane
square.com

LE BUN
lebun.co.uk

EL CAMION
25-27 Brewer St
London W1F 0RR
Tel: +44 20 7734 7711
elcamion.co.uk

■ **CELESTINE ELEVEN**
4 Holywell Ln
London EC2A 3ET
Tel: +44 20 7729 2987
celestineeleven.com

CEVICHE
17 Frith St
London W1D 4RG
Tel: +44 20 7292 2040
cevicheuk.com

DRINK, SHOP & DO
9 Caledonian Rd
King's Cross
London N1 9DX
Tel: +44 20 7278 4335
drinkshopdo.com

■ **FEATHERS**
42 Hans Crescent
London SW1X 0LZ
Tel: +44 20 7589 5802
feathersfashion.com

■ **GENEVIEVE**
Monkville Parade Finchley Rd
London NW11 0AL
Tel: +44 20 8458 9616
genevievesweb.com

THE LAUNDRY
2-18 Warburton Road
London E8 3FN
Tel: +44 20 8986 0738
thelaundrye8.com

THE LEDBURY
127 Ledbury Rd
London W11 2AQ
Tel: +44 20 7792 9090
theledbury.com

**THE LONDON
COCKTAIL CLUB**
londoncocktailclub.co.uk
Tel: +44 20 7580 1960

**GANGSTERS
TEQUILA PARADISE**
4 Great Portland Street
London W1W 8QJ

PUNK GIN PALACE
61 Goodge St
London W1T 1TL

**TATTOO RUM
PARLOUR**
224a Shaftesbury Ave
London WC2H 8EB

**UNDERGROUND
DIVE BAR**
6-7 Great Newport St
London WC2H 7JA

FARFETCH DIRECTORY

MANUKA KITCHEN
510 Fulham Rd
London SW6 5NJ
Tel: +44 20 7736 7588
manukakitchen.com

NIGHTJAR
129 City Rd
London EC1V 1JB
Tel: + 44 20 7253 4101
barnightjar.com

OLIVOMARE
10 Lower Belgrave St
London SW1W 0LJ
Tel: +44 20 7730 9022
olivorestaurants.com

■ **PRESS**
3 Erskine Rd
London NW3 3AJ
Tel: +44 20 7449 0081
pressprimrosehill.com

■ **PRIMITIVE LONDON**
29b Dalston Lane
London E8 3DF
primitivelondon.co.uk

■ **REWIND VINTAGE**
Tel: +44 20 7565 0886
rewindvintage.co.uk

RUBY'S
76 Stoke Newington Rd
London N16 7XB
rubysdalston.com

■ **SEFTON FASHION**
196 Upper St
London N1 1RQ
Tel: +44 20 7226 7076
seftonfashion.com

U.S.

AKASHA
9543 Culver Blvd
Culver City, California
90232
Tel: +1 310 845 1700
akasharestaurant.com

■ **ANASTASIA**
460 Ocean Ave
Laguna Beach, California
92651
Tel: +1 949 497 8903
anastasiaboutique.com

**BUSHWICK
COUNTRY CLUB**
618 Grand St
Brooklyn, New York 11211
Tel: + 1 718 388 2114
bushwickcountryclub.com

**THE BUTCHER'S
DAUGHTER**
19 Kenmare St
New York, New York
10012
Tel: +1 212 219 3434
thebutchersdaughter.com

**CHATEAU STE.
MICHELLE**
1411 NE 145th St
Woodinville, Washington
98072
Tel: +1 425 488 1133
ste-michelle.com

■ **CURVE**
154 N Robertson Blvd
Los Angeles, California
90048
Tel: +1 310 360 8008
shopcurve.com

■ **DAVID LAWRENCE**
700 110 Ave NE
Bellevue, Washington
98004
Tel: +1 425 688 1669
david-lawrence.com

■ **FORTY FIVE TEN**
4510 McKinney Ave
Dallas, Texas 75205
Tel: +1 214 559 4510
fortyfiveten.com

■ **GALLERY AESTHETE**
46 E Oak St
Chicago, Illinois 60611
Tel: +1 312 265 1883
galleryaesthete.com

JACK'S WIFE FREDA
224 Lafayette St
New York, New York
10012
Tel: +1 212 510 8550
jackswifefreda.com

JOHN HOWIE STEAK
11111 NE 8th St
Bellevue, Washington
98004
Tel: +1 425 440 0880
johnhowiesteak.com

■ **LINDA DRESNER**
299 W Maple Rd
Birmingham, Michigan
48009
Tel: +1 248 642 4999
lindadresner.com

LONGMAN & EAGLE
2657 N Kedzie Ave
Chicago, Illinois 60647
Tel: +1 773 276 7110
longmanandeagle.com

MELVIN'S JUICE BOX
Tel: +1 212 812 1482
melvinsjuicebox.com

DREAM DOWNTOWN
355 West 16th St
New York, New York
10011
Tel: +1 646 625 4825

MISS LILY'S
130 West Houston St
New York, New York
10012

MISS LILY'S 7A CAFÉ
109 Avenue A
New York, New York
10009
Tel: +1 212 812 1482

MR MESERO
4444 McKinney Ave
Dallas, Texas 75205
Tel: +1 214 780 1991
mrmesero.come

PINK TEA CUP
120 Lafayette Ave
Brooklyn, New York 11238
Tel: +1 347 227 7472
thinkpinkteacup.com

SANT AMBROEUS
265 Lafayette St
New York, New York
10012
Tel: +1 212 966 2770
santambroeus.com

SETTE MEZZO
969 Lexington Ave
New York, New York
10021
Tel: +1 212 472 0400

TOMMY'S BAR
5929 Geary Blvd
San Francisco, California
94121
Tel: +1 415 387 4747
tommysmexican.com

THE WILLOWS INN
2579 West Shore Drive
Lummi Island, Washington
98262
Tel: +1 360 758 2620
willows-inn.com

■ Indicates Farfetch Boutiques

FARFETCH
CURATES FOOD

EDITORIAL
Editorial Director Stephanie Horton
Editor in Chief Paul Brine
Features Editor Laura Hawkins **Fashion Features Editor** Alannah Sparks
Sub Editor Jason Dike
Editorial Consultant John Matthew Gilligan

ART
Creative Director Peter Stitson
Art Editor Craig McCarthy **Picture Editor** Robin Key

CURATORS
Tim Blanks, Jens de Gruyter, Leandra Medine, Tatiana Mercer (aka 'BarChick'), KF Seetoh, Tim Wendelboe

PICTURES
Breakfast with Elettra Kava Gorna
The Breakfast Club Photography by Catherine Losing, Food Styling Iain Graham
Healthy Measures vs. Guilty Pleasures Photography by Steve Joyce, Food Styling Iain Graham
The Guide to Modern Coffee Jake Curtis, Andrew Bret Wallis at Getty
Light Lunch with The Man Repeller Thomas Giddings
Singapore's New Food Fighters Weixiang Lim
Café Couture Anastasia Boutique photography by Joe Schmelzer
The Perfect Cup of Tea Michael Danner
A Parisian Pastry Tour Lowe Seger
Dinner Off the Beaten Path 'In De Wulf' by Piet Dekersgieter, 'Brae' by Colin Page
The New Fashion Capitals Gordon Flores
Women in Wine Thomas Giddings
A Vegetarian in Tokyo Hishashi Murayama
Iconic Cocktails Atelier Bingo
Winding Down with Jonathan Saunders Piczo

WORDS
Breakfast with Elettra Indigo Clarke
The Breakfast Club Laura Hawkins
Healthy Measures vs. Guilty Pleasures Laura Hawkins
The Guide to Modern Coffee Tim Wendelboe
Light Lunch with The Man Repeller Laura Hawkins
Singapore's New Food Fighters KF Seetoh
Café Couture Laura Hawkins, Alannah Sparks
The Perfect Cup of Tea Laura Hawkins
A Parisian Pastry Tour Alison Awoyera
Dinner Off the Beaten Path John Matthew Gilligan
The New Fashion Capitals Alannah Sparks
Women in Wine John Matthew Gilligan
A Vegetarian in Tokyo Alannah Sparks
Iconic Cocktails Tatiana Mercer (aka 'BarChick')
Winding Down with Jonathan Saunders Alannah Sparks

© 2015 Assouline Publishing
601 West 26th Street, 18th floor, New York, NY 10001, USA
Tel.: 212-989-6769 Fax: 212-647-0005
assouline.com
Printed in China.
ISBN: 9781614284369

FARFETCH
Harella House,
90-98 Goswell Rd,
London
EC1V 7DF
curates@farfetch.com